30-MINUTE LANDSCAPES

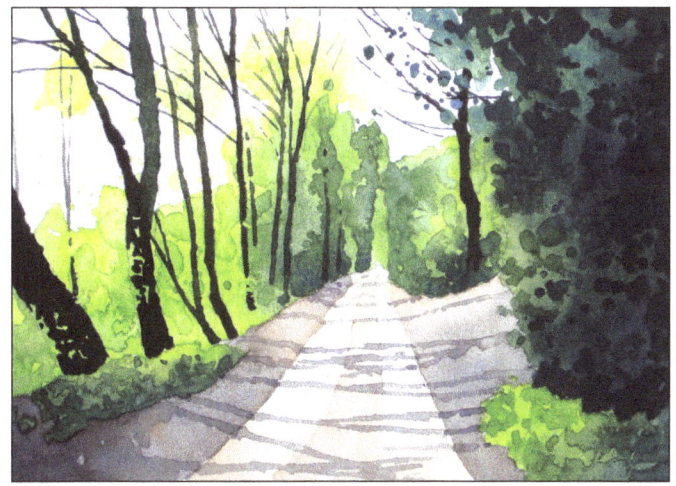

By Paul Talbot-Greaves

CONTENTS

Introduction..3
Tools and Materials..4
Watercolor Techniques..6
Sketching for a Painting...8
The Fresh Greens of Spring..10
Wet-into-Wet Reflections..12
Red Sky at Night..14
Using Contrast for Impact...16
Creating a Strong Focal Point.......................................18
Fill the Sky with Action..20
Winter Sunset...22
The Golden Colors of Autumn...24
Rainy Days..26
The Importance of Cast Shadows......................................28
Using White...30
Summer Trees..32
Winter Trees..34
Painting Buildings..36
Summer Showers..38
Working in Monochrome...40
Making Paintings out of Nothing.....................................42
Winter Mountains..44
A Misty Day...46
Waterfalls..48
Painting Snow Scenes..50
Using a Limited Palette...52
Around the Garden...54
Creating Patterns...56
Rendering Sunsets...58
February Light..60
Adding Animals to a Landscape.......................................62
Closing Words...64

Quarto is the authority on a wide range of topics.
Quarto educates, entertains, and enriches the lives of our readers—
enthusiasts and lovers of hands-on living.
www.quartoknows.com

© 2008, 2012 Quarto Publishing Group USA Inc.
Published by Walter Foster Publishing, a division of Quarto Publishing Group USA Inc.
Artwork © 2008 Paul Talbot-Greaves.
All rights reserved. Walter Foster is a registered trademark.

All rights reserved. No part of this book may be reproduced in any form without written permission of the copyright owners. All images in this book have been reproduced with the knowledge and prior consent of the artists concerned, and no responsibility is accepted by producer, publisher, or printer for any infringement of copyright or otherwise, arising from the contents of this publication. Every effort has been made to ensure that credits accurately comply with information supplied. We apologize for any inaccuracies that may have occurred and will resolve inaccurate or missing information in a subsequent reprinting of the book.

6 Orchard Road, Suite 100
Lake Forest, CA 92630
quartoknows.com
Visit our blogs @quartoknows.com

This book has been produced to aid the aspiring artist. Reproduction of work for study or finished art is permissible. Any art produced or photomechanically reproduced from this publication for commercial purposes is forbidden without written consent from the publisher, Walter Foster Publishing.

INTRODUCTION

Often beginners are intimidated by the amount of time they think they need to invest in a painting, but it's important for them to realize that painting doesn't have to be an all-day event. As an exhibiting artist and instructor, I often am asked, "How long does a painting take?" When I give an honest answer, people are amazed at how little time it takes to complete a competent scene in watercolor. If you can set aside 30 minutes in a day, you can create a beautiful, luminous watercolor painting. To prove it, I have developed 27 step-by-step landscape lessons that can be completed within a half-hour.

As you follow the lessons in this book, you'll soon discover the benefits of painting quickly. Many beginning watercolorists tend to overwork their paintings, muddying the colors and disturbing the paper's surface with layer after layer of paint. And beginners often add too much detail to their paintings, creating a busy mess without a focal point. However, it's not about what you put into a painting—it's what you leave out! To help you avoid overworking your paintings, I've broken down each lesson into blocks of time. By using the suggested minutes as a guide, you'll find that your colors will stay vibrant and your strokes will be looser and fresher than ever before. See for yourself—turn the pages for an exhilarating, eye-opening experience with watercolor!

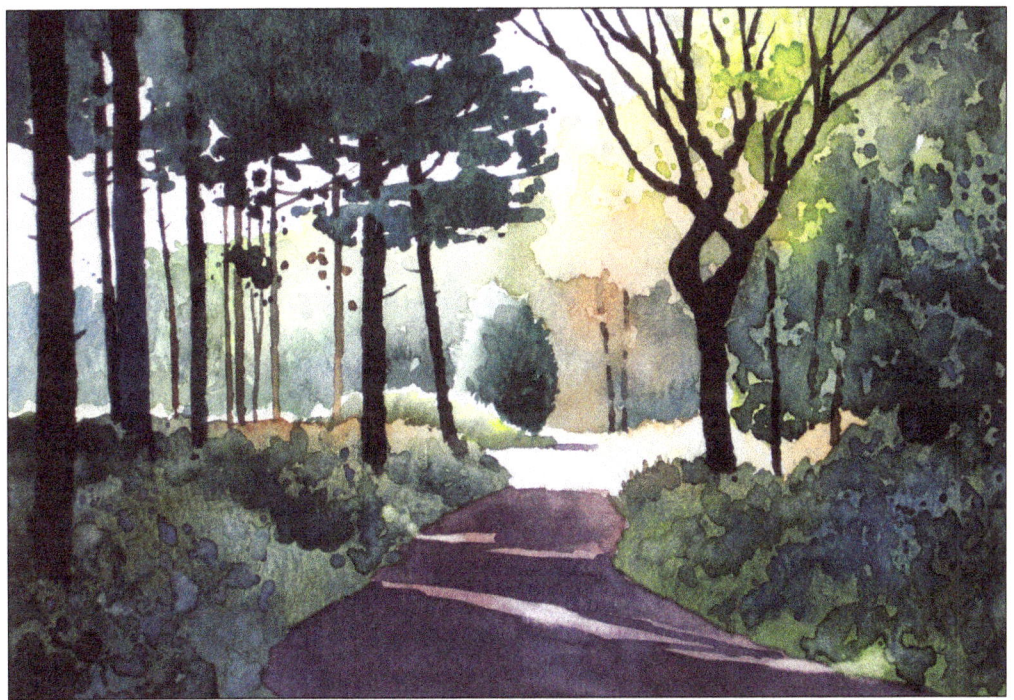

TOOLS AND MATERIALS

In today's market, there is an extensive array of painting equipment to choose from. A visit to the art store can be an exciting prospect, especially for an impulsive artist like myself, yet we need only a few basic items to create the paintings we want. Over the next two pages, I'll discuss the materials you'll need to complete the projects in this book. Remember that it's best to purchase the highest-quality materials you can afford, as they produce better and longer-lasting results.

Paints

Watercolor paints come in dry *cakes* (blocks of pigment), *pans* (semi-moist wells of paint), and tubes. For cake and pan paints, you must loosen the pigment by stroking over it with a wet brush. I prefer to use tube paints because they mix readily with water, giving me quick results—I don't have to spend time loosening pigment with my brush to create large or intense washes (see page 6). I believe tube paints also are more sympathetic to brushes, as there is very little "scrubbing" required. When working outdoors, I use an old pan set for convenience, then touch up with tube color as necessary.

Paper

It always is important to use a good-quality watercolor paper if you want to achieve the best possible results. Watercolor papers come in a range of textures: *hot-pressed,* which is smooth; *cold-pressed,* which has a medium texture; and *rough,* which has plenty of *tooth* (or raised areas of paper). I sometimes use a rough, 300-lb paper for landscape work when I wish to utilize the surface texture, but usually I use a stretched piece of 140-lb cold-pressed paper, as I prefer the feel of this weight. (See page 7 for information on stretching your watercolor paper.) For paintings with a great deal of light, tone, and contrast, I generally use a cold-pressed paper with a brilliant white tone, which helps create the illusion of reflected light and leaves the finished piece with a beautiful sheen.

◀ **Purchasing Tube Colors** To complete the projects in this book, purchase the following colors: alizarin crimson, burnt sienna, burnt umber, cadmium red, cadmium yellow, cobalt blue, French ultramarine, Hooker's green, lemon yellow, light red, Naples yellow, Payne's gray, Permanent rose, Prussian blue, raw sienna, sap green, violet, and white gouache.

Paintbrushes

There are many kinds of paintbrushes available, but they can be narrowed down to two types: synthetic and natural hair. Synthetic brushes usually are less expensive than natural ones, but I find that they don't retain water as effectively as natural-hair brushes, which is very important when painting in watercolor. For this reason, I use kolinsky sable brushes (cut from the hairs of the tail of a mink native to Siberia). Sable brushes hold a large amount of paint, their bristles have a good spring, and they form a very fine point.

For most of my work, I use a range of round brushes: one very small, one small, two medium-sized, and one large. For detail work, I use a #1 synthetic rigger brush, as I find the bristles of sable riggers to be too fine. For larger washes, I use a 1" or a 1/2" flat sable brush. I also use a stiff bristle brush to scrub paint off the paper's surface. (See "Lifting Out Color" on page 6.) Throughout the projects, I don't always mention the exact brush I use for an action; when following the lesson instructions, simply use the brush that best suits the stroke and size of the area you are painting.

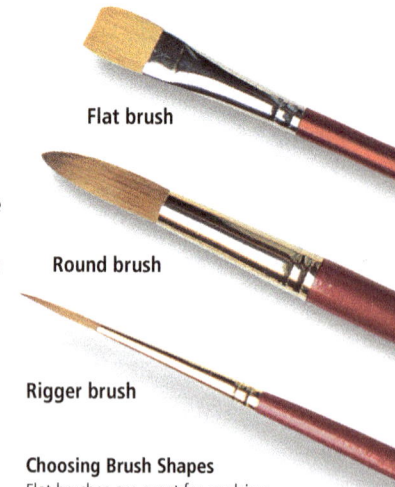

Flat brush

Round brush

Rigger brush

Choosing Brush Shapes
Flat brushes are great for applying thick strokes and washes, whereas round brushes are better for more detailed work, as their bristles taper to a point. Rigger brushes (the smallest of the rounds) are ideal for intricate brushwork.

Palette

I spent years trying to find a palette with enough mixing space to really push the colors around, and eventually I discovered what I had been looking for. I didn't end up with a conventional artist's palette; instead, I use a 16" x 12" food display tray made of white plastic. I squeeze out my colors along the edges and use the middle for spreading out my watercolor mixes. When the palette becomes messy, I simply rinse it out with water. If you prefer, purchase a paint palette at your local art store with wells wide enough for your largest brush and deep enough to hold a good amount of wash.

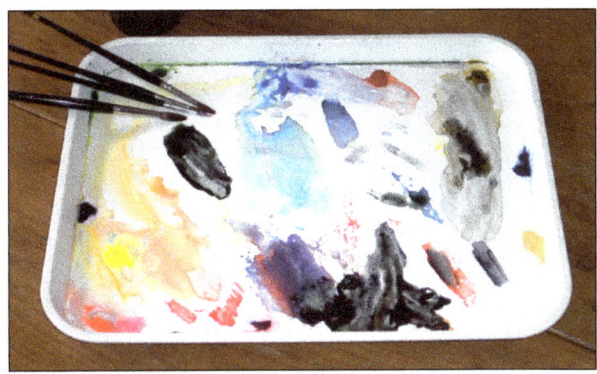

My Palette of Choice These food display trays come in various sizes and are available in a brilliant white, which allows you to see paint colors accurately.

Pencils and Erasers

Pencils are labeled with numbers and letters to indicate their level of hardness or softness. "H" pencils are hard, and "B" pencils are soft; the higher the accompanying number, the more intense the hardness or softness. It's important to use minimal pressure and a soft pencil when sketching on watercolor paper, as hard pencils can be too light to see through washes and easily can score the surface of the paper. For cold-pressed paper, I use a soft 4B pencil; for rough paper, I use a 2B or 3B. I use a soft kneaded eraser to remove any unwanted pencil marks, as this eraser is gentle on the paper's surface and doesn't leave crumbs. Vinyl, rubber, or gum erasers can leave unsightly marks on the paper.

Other Materials

For wiping my work surface and lifting color from a painting (see page 6), I use paper towels. I use a small bucket to hold my water. The bigger the container, the less frequently you have to change the water. To preserve whites, I also use masking tape to create a border around the edge of my work. To prevent the tape from ripping the paper when I remove it, I use a hair dryer to warm the glue as I slowly peel off the tape. It always works! The hair dryer also is good for speeding up the drying time of the paint. (I hold it at least 10 inches from the paper on a low setting, and I make sure to use a cool setting when drying masking fluid so it doesn't bake into the paper.) I also keep a craft knife on hand to sharpen my sketching pencils.

Workspace

Watercolor painting doesn't require much space, but it's best if you can designate an area exclusively for your work. There is nothing worse than having to clear your supplies from the table at meal times, as this interrupts your creative flow and creates extra work. I generally work with my paper flat on the tabletop and my materials arranged within reach. I try to paint in natural light, but if I work in the evening, I use a daylight simulation bulb for a clear light.

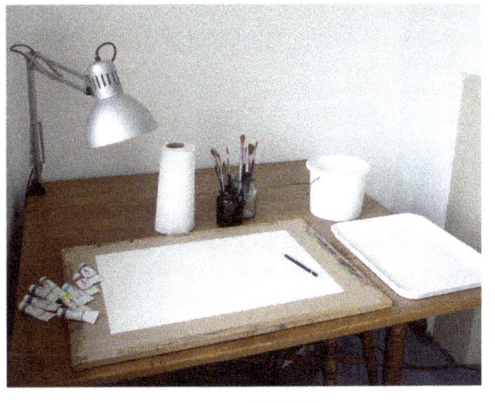

WATERCOLOR TECHNIQUES

There are many ways to apply paint to your paper, and the way in which you apply it can help suggest the character of your subject. The following pages feature important watercolor techniques that I use throughout the projects. Before employing them within a painting, gain confidence and control through practice.

Flat Wash A flat wash is an even layer of diluted color you can use to tone large areas of your painting, such as the ground or a body of water. First tilt your support at a slight angle; then load your brush with heavily diluted color, and make even strokes over the area. Each stroke should overlap the previous, picking up any drips of the previous strokes.

Gradated Wash A gradated wash is an area of color that gradually fades in intensity, which is perfect for rendering skies. Begin by stroking a band of color across the paper. Then add more water to your brush, and make another stroke so it slightly overlaps the first. Continue overlapping strokes, dipping the brush in water before each stroke. The color will lose intensity, creating a smooth blend of dark to light.

Variegated Wash A variegated wash is a wash created with two or more colors. Instead of a flat area of color, this wash can vary in tone, color, and intensity. I often use this type of wash as the first layer over foliage or clumps of leaves, as it offers visual interest and depth—even after adding layers of paint over it. Simply apply several different washes of color next to one another, allowing the colors to touch and bleed. (Experiment to make sure bordering colors within the wash won't gray when blended.)

Lifting Out Color Not all techniques involve applying paint—you actually can achieve a number of effects by removing paint from the paper's surface. Lift out color to create a sunburst as part of a sunset, reinstate highlights, or suggest reflections in water or glass. First make sure the painted area is thoroughly dry, and then use clean water to reactivate the pigment. Using a small bristle brush, scrub away the desired areas of paint. For larger areas, I use a dry or semi-moist sponge to lift out the color. You also can touch up areas by dabbing wet paint with paper towels.

Scumbling Use this technique to suggest many different textures and features found in landscape scenes, such as hard-edged clouds, rocky shores, or gravel pathways. For best results, perform this technique using rough paper and a large, soft round brush. Load your brush with color, and then wipe it gently using a paper towel to get rid of excess moisture. Hold the brush parallel to the paper and use the side of the bristles to lightly move back and forth over the paper's surface. The brush should just graze the paper surface, dusting paint onto the tooth of the paper.

Stippling I use this technique to suggest falling, splashing water and leaves on trees. With your paper flat on the working surface, hold the brush at a steep angle and randomly "dot on" the paint with the tip of the brush. Be sure to use a light touch and keep your brush steady. Stipple randomly, varying the sizes of the dots by applying more or less pressure to the brush. Some of these will merge so that the effect isn't overdone. You'll get the best results using a blunt round brush. (A fine-pointed brush doesn't create the soft, rounded shape that this technique requires.)

Wet into Wet This technique encourages paints to blend on their own; the colors will run and bleed, creating soft edges and lively patterns. Use at least 140-lb paper and, for larger paintings, stretch it to avoid buckling (see below). Then lay the paper flat and use a large flat brush to apply generous amounts of water to the paper's surface. Keep the brush in contact with the paper and push the water around in every direction so that you cover the paper evenly. When the water settles into the sheet, apply a second layer of water in the same manner. Once the paper has an even, satin sheen with no drying areas or pools of water, apply diluted paint.

Spattering Spattering is a great way to create random texture over an area. It can be rather messy, so if you already have completed parts of the painting, protect them from paint droplets by masking the areas with sheets of scrap paper. I often use spattering to suggest the random, mottled textures found in foliage and rough areas of ground. And I sometimes employ a careful spattering technique in snow scenes using Chinese white or white gouache. For this technique, load a medium-sized round brush with paint and use your index finger to tap the handle, releasing dots of paint onto the paper. Build up the spattered area and allow it to dry flat on your working surface.

Stretching Your Watercolor Paper

Stretching will prevent lighter-weight papers from buckling when water is applied. Generally, any paper lighter than 200 lbs should be stretched. You'll need a ruler, a pencil, scissors, masking tape, a sponge, and a board or another flat surface. Use the ruler to draw light pencil lines about half an inch away from the edges of the paper to help you align the tape. Fill a sink, tub, or large tray with clean water, and then briefly immerse the paper (A). Turn the paper over once to make sure both sides are evenly and thoroughly wet. Place the paper on your board or flat surface, and smooth it out with a damp sponge to remove any creases or bubbles in the paper (B). Place a strip of tape along each edge of the paper, smoothing it with your hand as you go (C). Trim away the excess tape with scissors, and then stand the board upright and allow the paper to dry for at least two hours before using it.

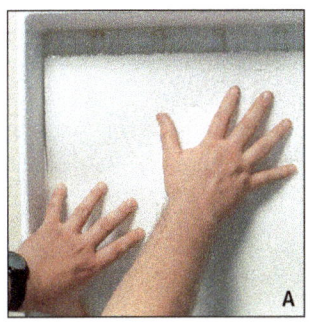
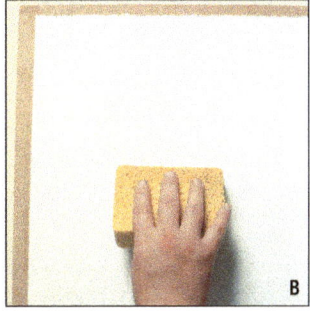
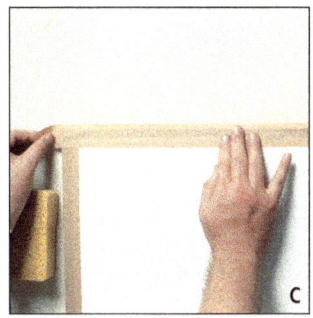

SKETCHING FOR A PAINTING

A sketch for a painting doesn't need to be a detailed, in-depth study. I view the sketch as a simple guideline—a map to show you where you are going. But just as you wouldn't follow a map inch by inch as it's laid out, don't follow the drawing line by line as you paint. In fact, try to view the painting process as sketching with a brush. The pencil lines are there to show you where one section stops and the other starts, but it doesn't matter if you paint over them a bit.

With this in mind, concentrate only on placing the main shapes accurately. For instance, if you were drawing a brick wall, you would need to establish the top and bottom of it but not all the brick detail. A well-constructed drawing will provide a solid foundation for a confident painting, so don't rush the pencil work.

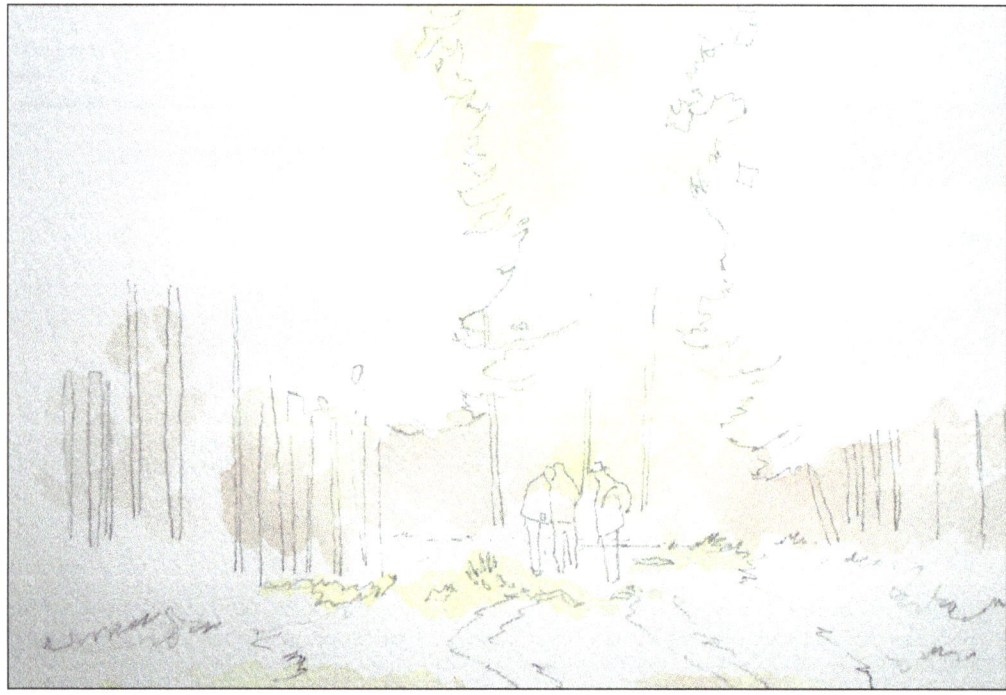

Keeping It Simple Here I've indicated with loose lines only what I need to begin painting: the division of trees and sky, a few tree trunks, the figures, the pathway, and some areas of foliage. Notice how you still can see my pencil lines through the first wash.

Tips for Beginning Your Sketch

- As discussed on page 5, it's best to use a soft grade of pencil for sketching, such as a 3B or 4B, as harder grades can create irreversible indentations and marks on the paper. Also, stick with a kneaded eraser to be sure you don't damage the paper's surface.

- Aim for reasonably strong pencil marks so the lines will continue to show as you add more and more layers. I often see students using delicate, faint lines only to find their hard work disappear beneath the first wash!

- Try not to smudge the graphite across your watercolor paper as you draw, as this can muddy your washes. If you do create a smudge, dab up the graphite with your kneaded eraser.

- Sharpen your pencils with a craft knife as opposed to a pencil sharpener. A knife can pare away more of the wood and expose more graphite. You can then shape the graphite into a chiseled point, giving you the ability to draw both fine and thick lines with a simple twist of the pencil. The nib of the pencil also lasts longer when sharpened with a craft knife.

Laying In the Sketch

As you draw, constantly compare your drawing's shapes, angles, and proportions with your photo reference. Work from the center of the paper out toward the edges, plotting lines and shapes very faintly. This way you won't have any trouble removing the lines if they're wrong. Once the general structure of the drawing has been mapped out, a darker, more confident line can be placed on top.

Other Sketching Methods

If you find drawing difficult, there are other methods to assist you, some of which are described here. Remember that you shouldn't rely on these methods as a replacement for untrained skills. If you desperately want to improve your drawing skills, simply keep on drawing!

Using Grids

You can transfer the outlines and shapes of your reference using the grid method, which helps you break down the picture into smaller sections. First draw a grid over your photograph (I use 1/2" squares). Then draw the same grid lightly on your watercolor paper. Draw larger squares to increase the image size; draw smaller squares if you want to decrease the image size. (Remember that the reference and your watercolor paper must have the same number of squares.) Once the grids are in place, simply draw what you see in each square of the reference in each square of the paper.

Tracing

For complicated drawings, tracing can save corrective work on the watercolor paper. Begin by drawing the image on an ordinary piece of paper, erasing and redrawing as needed. Once you're happy with the image, cover the back of the paper with an even layer of graphite. To transfer the image, place the drawing over your watercolor paper and lightly trace over the lines.

Projecting

An opaque image projector, such as an Artograph® or Kopykake®, is a quick (albeit somewhat expensive) way to sketch for a painting. You can use this machine to cast an image of your photo reference onto your watercolor paper, allowing you to trace the lines of the image. Don't let the projector tempt you to include every element, which can lead to a "paint by numbers" approach. Use the projector simply to check or establish proportions.

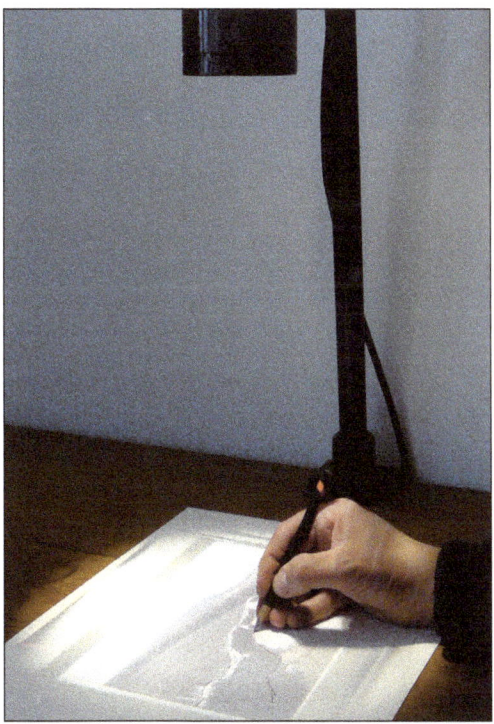

Using an Opaque Image Projector The subject needs to be in the form of a printed photograph or small drawing, which is clipped inside the light box. The image is then illuminated by a light, reflected in a mirror, and projected through a lens onto your paper.

> ### Composing a Landscape
>
> *Effective* composition—*the arrangement of elements within a painting—is essential for creating a dynamic piece of art. Although the rules of composition require the artist to keep certain guidelines in mind, there is no real right or wrong solution. In landscape painting, the first step is to make sure your painting contains three basic compositional elements: a lead-in element (such as a winding pathway that directs the viewer's eye into the painting), a focal point (or area of interest), and a strong background (which supports—not overpowers—the focal point).*

 30 Minutes

THE FRESH GREENS OF SPRING

Landscapes containing a great deal of green can tend to look a bit monotonous, especially when lacking a strong light source. Introducing sunshine to flat, lifeless greens turns them into a kaleidoscope of vivid colors. In this painting, I aimed to capture the freshness of a bright spring day—the perfect time of year for an exciting watercolor interpretation of greens. To keep my greens vibrant and avoid any muddiness, I limit myself to only 6 colors and 30 minutes.

PALETTE
burnt sienna, French ultramarine, lemon yellow, Payne's gray, sap green, and violet

EXTRAS
masking fluid and an old brush

STAGE 1

7 minutes After lightly sketching the scene, I mask out the rough shapes of the bluebells by applying masking fluid with the handle end of a brush (see page 17). When this is dry, I freely add the pale greens of the trees using a medium round brush and varied mixtures of lemon yellow, sap green, and French ultramarine. As I brush the paint on the paper, I deliberately spatter the color to suggest leaves. I use a stronger wash of sap green for the grass. To vary the overall color, I add French ultramarine and lemon yellow wet into wet; this will cool and warm areas, respectively.

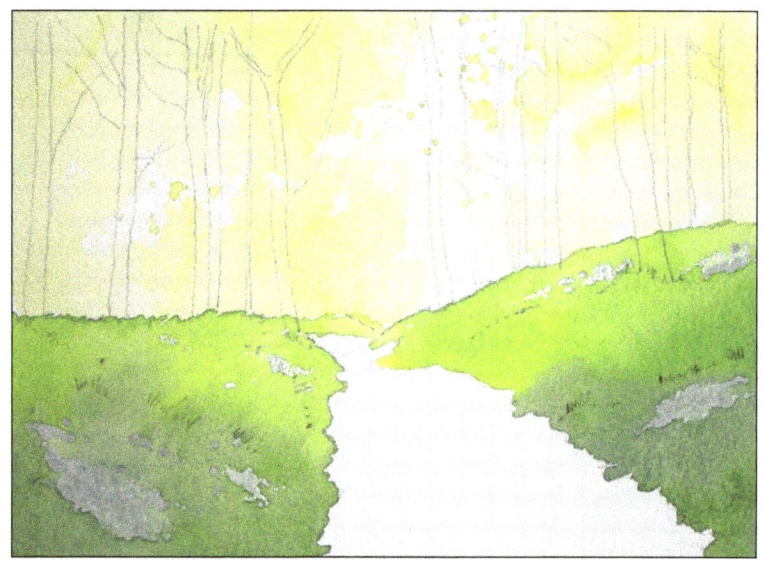

STAGE 2

4 minutes I mix some French ultramarine with sap green and create a second layer of leaves on the trees. This time I leave spots of the first wash showing—especially where the light will be strongest—and I again spatter some of the wash onto the paper. This application of spattering, although it appears very loose, is actually quite deliberate. As the tree area dries, I fill in the path with washes of burnt sienna and Payne's gray, which I mix directly on the paper.

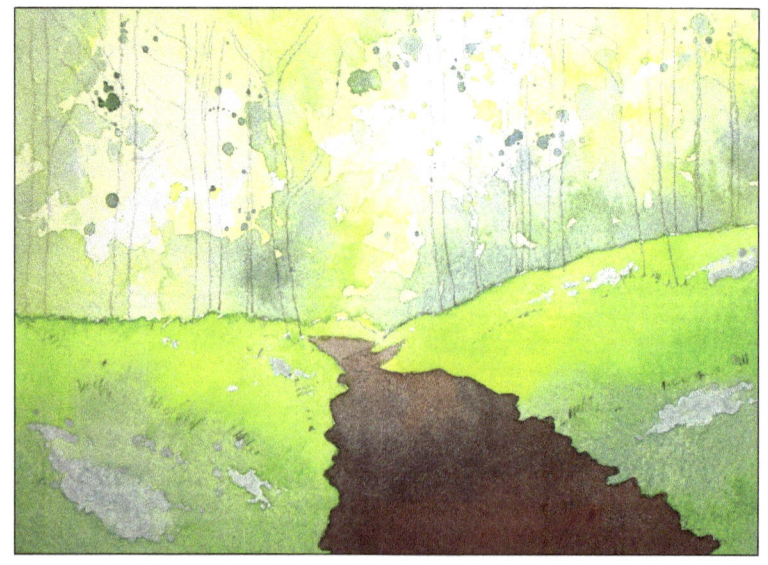

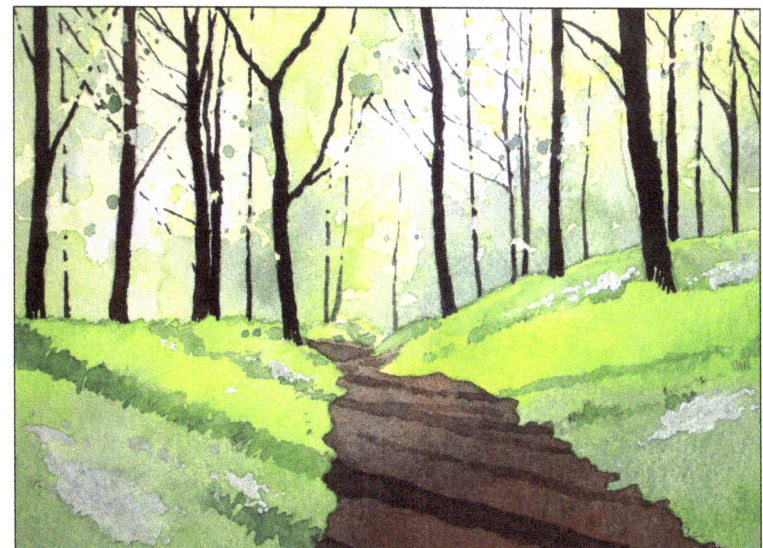

STAGE 3

12 minutes Once the washes are dry, I add some cast shadows across the foreground grass using a mix of Payne's gray and sap green, which is a stronger, grayer green than the wash that is already present. I also strengthen and gray the mixture I used for the path to create the cast shadows that fall across it. To paint the tree trunks, I use a very small round brush loaded with a strong mix of Payne's gray and burnt sienna. I spend a few minutes carefully re-creating the shapes and tapers of the branches.

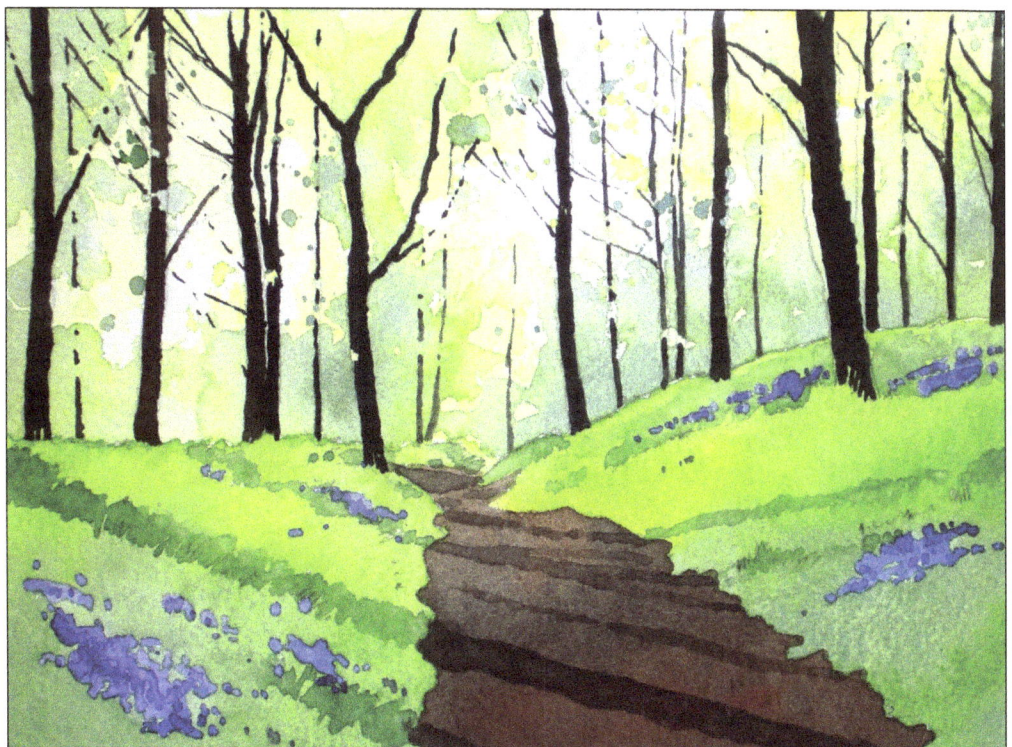

STAGE 4

7 minutes Now I remove the masking fluid and tint the freshly revealed areas with a vibrant mix of French ultramarine and violet. The use of masking fluid ensures that I can paint the bluebells on pure white paper, which makes them bright and clean. The painting looks complex, but it consists of only a few simple but deliberate stages—all of which can be completed within a half-hour!

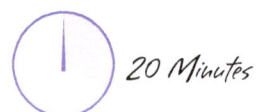 *20 Minutes*

WET-INTO-WET REFLECTIONS

Wet into wet is one of those hit-or-miss techniques—it generally either produces brilliant results or becomes a complete mess. There never seems to be an in-between. There are, however, a couple of factors that will dramatically improve the success of the technique. First, select a good paper that will hold water well. (This technique requires that your paper stay wet for some time.) Some papers, especially lighter-weight papers, absorb liquid so well that the water disappears before you can apply any color. Second, make sure that you begin with a liberal application of water. I generally cover the area with clean water and allow it to soak in for a few minutes. Then I apply a second, and maybe even a third, layer before I begin to paint. This ensures that the paper fibers are thoroughly soaked, which gives me more time to push the paint around before it dries. Preparation is definitely the key!

PALETTE
burnt sienna,
French ultramarine,
Hooker's green,
raw sienna,
sap green, violet,
and white gouache

EXTRA
hair dryer

STAGE 1

4 minutes I draw the tree and the shapes of the bank on my watercolor paper. With a medium round brush, I loosely apply a variegated wash of sap green and French ultramarine into the background. While the wash is still wet, I use a strong mix of Hooker's green and French ultramarine to suggest the soft shapes of the distant trees. I deliberately work around the main tree shape, as I want to make it lighter than the background.

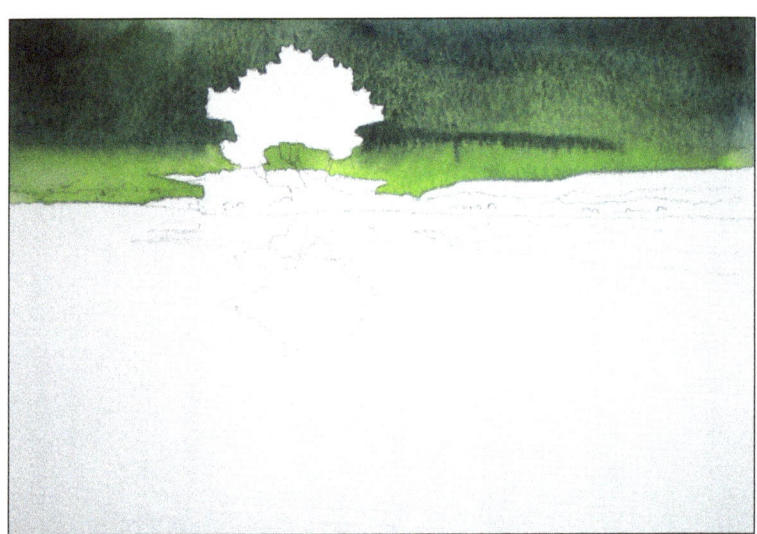

STAGE 2

8 minutes Next I work on detailing the foreground. I use a very small round brush to paint the tree with a variegated wash of sap green and French ultramarine. While this dries, I wash burnt sienna and raw sienna into the areas of erosion on the bank. After a quick dry with the hair dryer, I use a dark mix of burnt sienna and French ultramarine to paint the tree trunks and branches. Next I use a wet brush to cover the dark parts of the bank and then paint over them with the burnt sienna and French ultramarine wash for a soft look.

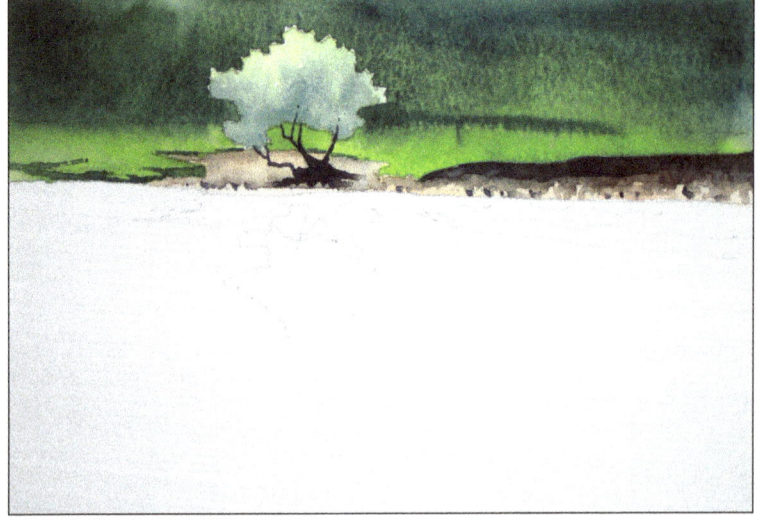

STAGE 3

8 minutes Now I prepare the paper for the wet-into-wet application of the river by wetting the paper thoroughly with three layers of water, allowing the water to settle between layers. When the paper takes on an even sheen, I apply a thin wash of French ultramarine over the entire area. Then, using a strong wash of sap green, I paint around the tree reflection and across the bank. For the eroded areas, I use raw sienna and burnt sienna. Next I use strong Hooker's green mixed with French ultramarine for the darker reflections, replacing the French ultramarine with violet as I move down. I paint the reflections of the tree trunks last with a strong mix of French ultramarine and burnt sienna. Once the paper is dry, I add a couple of finishing touches. First I dampen a 1/4" chisel-edged brush (a small flat brush would work as well) and skate it sideways across the water to lift out a few horizontal highlights. Finally, I add several sun-kissed spots using white gouache. Although this wet-into-wet section looks complicated, properly wetting the paper allows the paint to flow easily.

Details

Stroking Vertically When you introduce violet into the wash toward the bottom of the painting, use vertical strokes to suggest the darker background trees that are above the scene, just out of the shot.

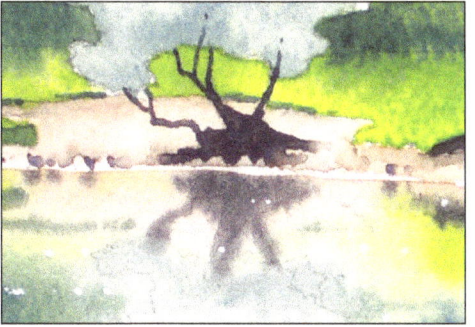

Creating Reflections For realistic reflections in the river, keep the colors and strokes softer than when painting the actual objects. Be sure that the river is wet before adding details, such as the tree trunk, so the paint spreads to create gently blurred edges.

 20 Minutes

RED SKY AT NIGHT

Nevermind the shepherd—the old adage of weather prophecy ought to be amended to "red sky at night, artist's delight." Sunsets are attractive features of our daily lives, but it's often at the eastern end of the planet where the best display of colors can be seen. Here the cooler side of the spectrum—crimson, violet, and blue—often is clearly visible. It's a wonderful thing to be able to watch the changing colors of the sky, and it's even better to be able to record them. I completed this painting in only 20 minutes—working quickly allowed me to create a vibrant, variegated sky wet into wet.

PALETTE
cadmium red, cadmium yellow, cobalt blue, French ultramarine, and permanent rose

STAGE 1

9 minutes I draw the simple row of buildings on a piece of 200-lb extra-rough paper. I prepare for a wet-into-wet wash, wetting the entire sky with clean water. (See page 7 for full wet-into-wet preparation instructions.) I complete this stage while the sky is still wet. I begin in the lower sky area, using a flat brush loaded with a mix of cadmium yellow and permanent rose. Above this, I brush in permanent rose to form the bursting shape in the sky. Then I add light washes of cobalt blue around them. Finally, I suggest the soft background hills at right with a strong mix of cobalt blue and permanent rose.

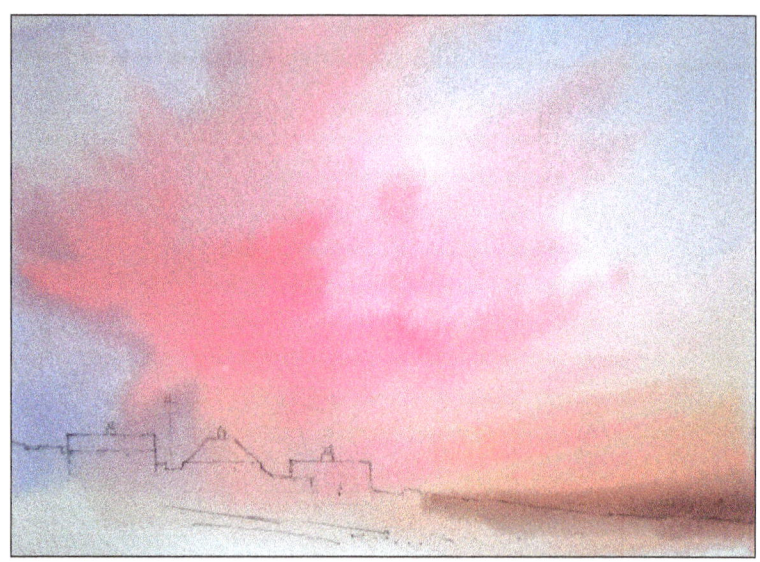

STAGE 2

4 minutes Once the washes have dried, I deepen the sky colors by adding a second layer of washes using the wet-into-wet technique and the same colors from stage 1. I very carefully re-wet the painting with clean water and repeat the painting process, using light, gentle strokes so I don't disturb the original washes. This enrichment of color enhances the sense of dimension within the sky.

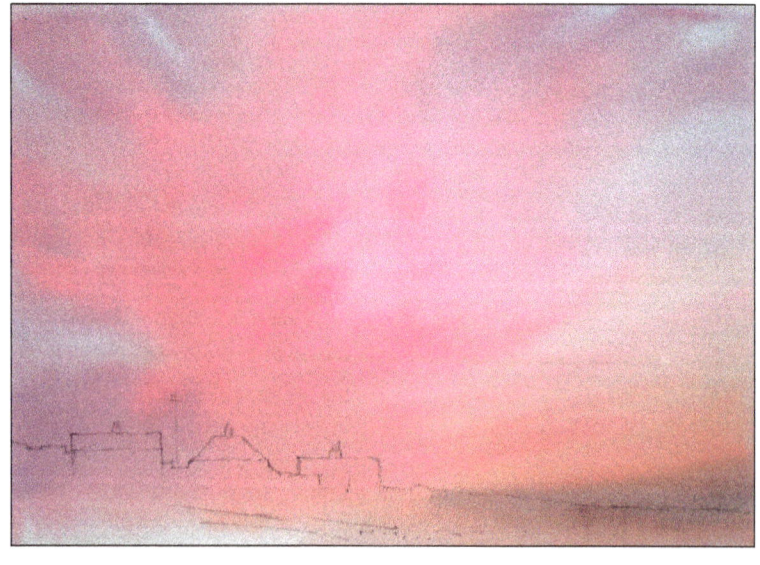

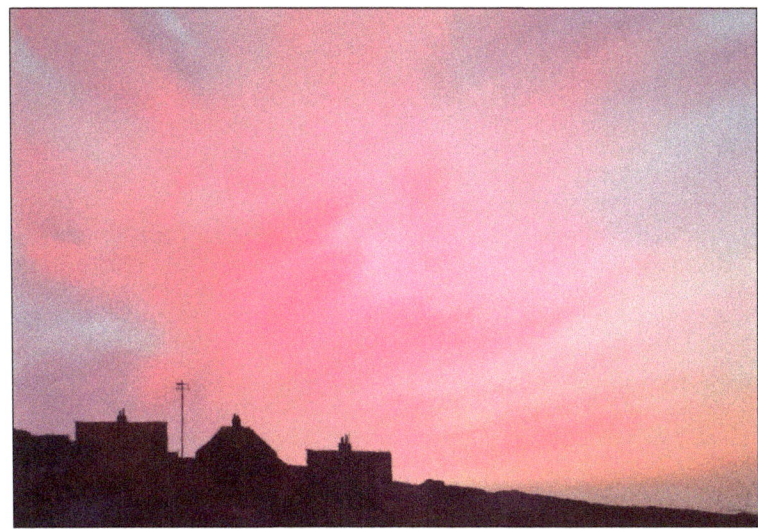

STAGE 3

4 minutes I work on the land section of the painting using very strong washes of French ultramarine and cadmium red. I choose these colors to create the dark foreground silhouette because they will harmonize better with the colors of the sky than black would. I carefully paint the shapes of the buildings and land, applying the colors separately and letting them merge on the paper (instead of on my mixing palette) for variation and interest.

STAGE 4

3 minutes I finish the painting with some very subtle detail in the land area using a mix of French ultramarine and cadmium red. I add one or two abstract shapes suggesting roofs and windows; although barely visible, they add solidity to the foreground.

- Reds and yellows (especially the cadmiums) are very strong, so thin them with plenty of water before you paint.
- Work up multicolored skies starting with yellow and moving through orange and red to finish with blue. Place the individual colors only where they need to be and let them blend together softly where they meet.
- Creating strong, dark colors in the land will amplify the lighter colors of the sky.

 30 Minutes

USING CONTRAST FOR IMPACT

Tone (the quality and depth of a color) is perhaps the most important aspect of painting, and the more I have studied this topic, the more my own artistic perception has gradually changed over the years. At this point in my painting career, I find myself led more and more by tone and contrast rather than by the subjects themselves. I look for patterns of tone and light before the subject has even registered; this allows me to quickly create visually striking paintings while keeping the image simple and approachable. I was inspired to paint this scene because of the high contrast and strong sense of light and shadow. The figure creates an excellent focal point and draws further attention to the gateway, where the tonal extremes border one another.

PALETTE
French ultramarine, Hooker's green, lemon yellow, light red, Payne's gray, raw sienna, sap green, and violet

EXTRAS
masking fluid and an old brush

STAGE 1

4 minutes I begin by reserving a few white areas in the foliage with masking fluid, which takes only a few seconds. The masked areas appear as blue spots in the image. (See "Using Masking Fluid" on page 17.) Then I paint the building with a very pale wash of light red. Next I fill in the grassy areas with washes of sap green, adding touches of lemon yellow, raw sienna, and French ultramarine wet into wet for color variations.

STAGE 2

6 minutes As soon as the previous washes are dry, I start applying darker colors. I add strong washes of Hooker's green, Payne's gray, French ultramarine, sap green, and violet with a medium round brush, mixing them on the paper. I keep the coolest colors, such as Payne's gray and ultramarine, in the shadowed areas, and I reserve the warm sap green washes for sunlit areas. I approach the overall wash using loose brushstrokes to give it a fresh and airy feel.

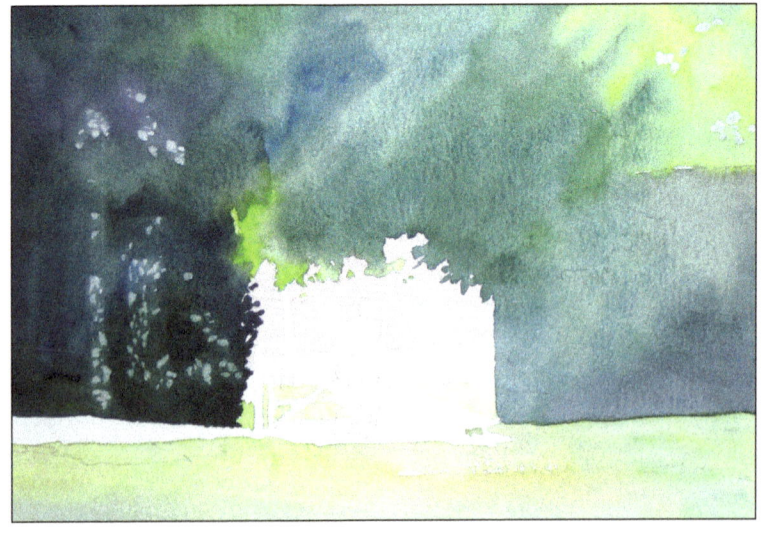

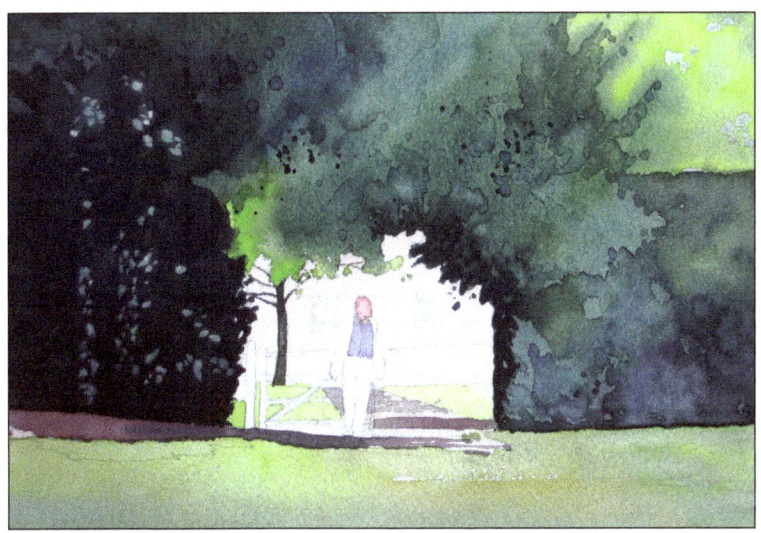

STAGE 3

10 minutes I decide that some of the darks need more emphasis, so I return to these areas with mixtures of Hooker's green, Payne's gray, French ultramarine, and violet. As I apply darker washes, I create form within the foliage and try to keep it flowing and spontaneous. I even spatter paint (see page 7) onto the paper in areas. While the main wash dries, I paint some of the shadows on the ground using light red mixed with French ultramarine. Then I begin painting the figure, using only colors I have already used in the landscape for a sense of unity.

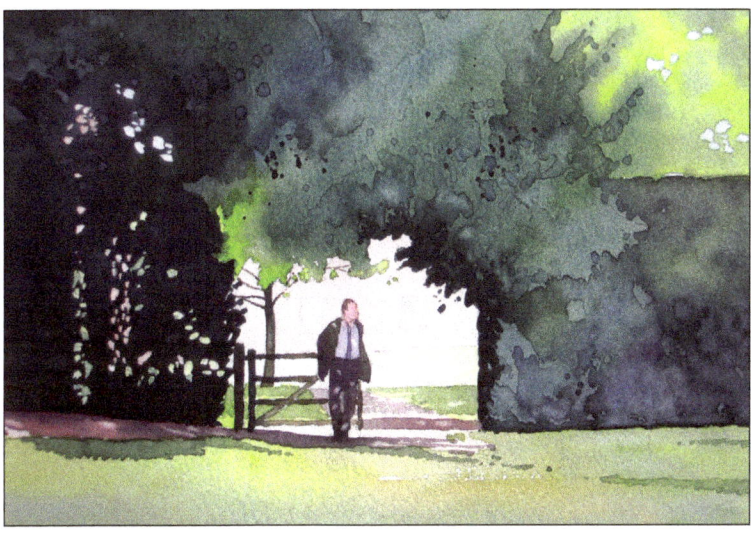

STAGE 4

10 minutes I remove the masking fluid and tint areas that are now plain paper. I use pale washes of sap green and light red to tint the areas at left, as shown, and I use pale French ultramarine for the areas at right. I finish the figure, add the thin lines defining the gate, and put in more cast shadows on the grass. For the finishing touches, I lift out some small areas of paint on the pathway and figure with a damp brush to create the effect of dappled light.

Using Masking Fluid

Masking *refers to temporarily protecting specific areas of a painting to keep them from being covered by paint. Many watercolorists use* masking fluid, or liquid frisket, *which is a latex-based substance. Use an old brush to apply the masking fluid over areas that are meant to remain white (A). When dry, the frisket repels paint, so you can paint over it without covering the white support underneath (B). When the paint is dry, gently rub or pull off the frisket with your fingers to reveal perfectly shaped areas of pure white (C).*

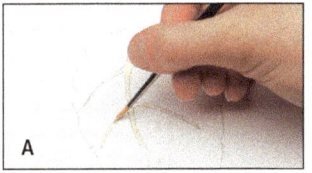
A

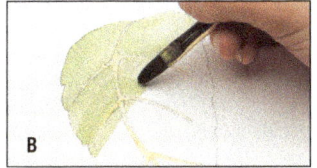
B

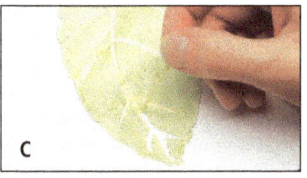
C

12 Minutes

CREATING A STRONG FOCAL POINT

When I ask a workshop group to bring in photo references for painting, most people bring photos that lack a focal point. The reference may have some pleasing aspects, but it may not make an effective painting. Remember that there are ways to salvage a reference—you're not bound to use the photo as it is. You are free to enlarge, move, or change the color of any element to enhance or create a focal point. In this project, I'll show you how I use light to create a strong focal point.

PALETTE
burnt sienna, cadmium red, French ultramarine, lemon yellow, and Payne's gray

STAGE 1

3 minutes After sketching the main shapes of the composition, I block in the entire mountain (but avoid the cottage in the lower left corner), starting with a pale wash of lemon yellow at the light break. Next I graduate the wash (see page 6) into a green mixture of lemon yellow and French ultramarine. Then I add a touch of Payne's gray to the mix to make the wash stronger and darker toward the edges of the mountain. I use a large round brush to apply the paint quickly so unwanted edges don't form on the mountain.

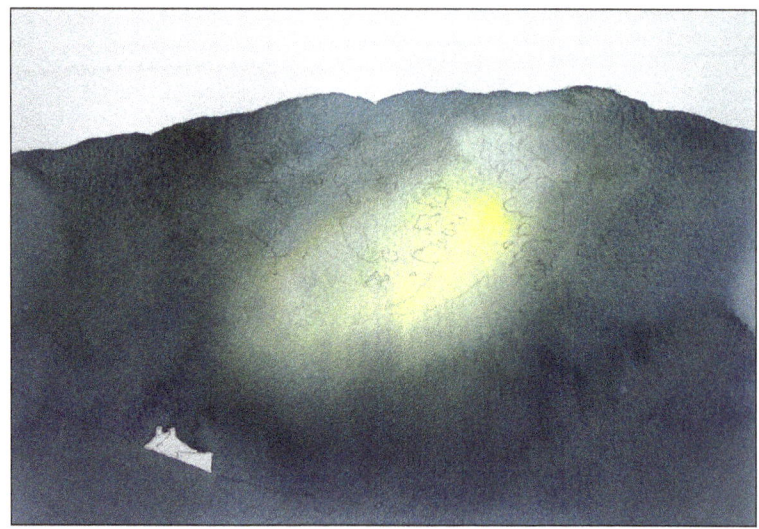

STAGE 2

5 minutes Now I work with burnt sienna and French ultramarine to rapidly create the rock shapes with the tip of a large round brush. I use a pure burnt sienna wash where the light is hitting the mountainside, adding French ultramarine as I move into the shadowed areas.

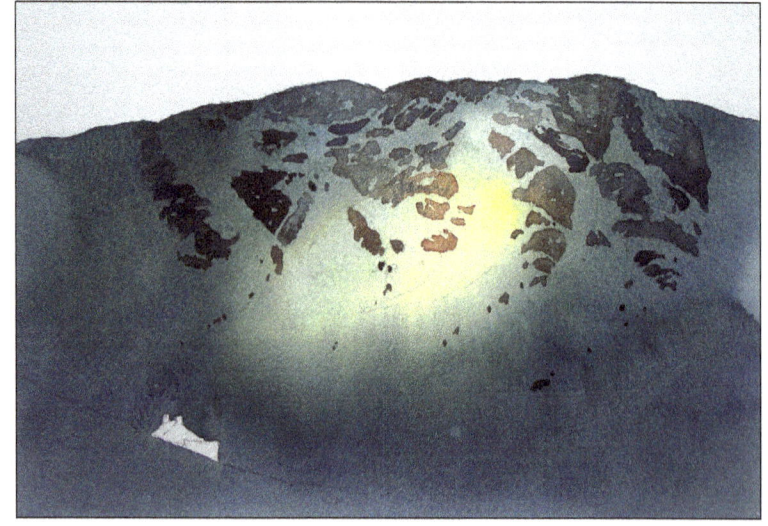

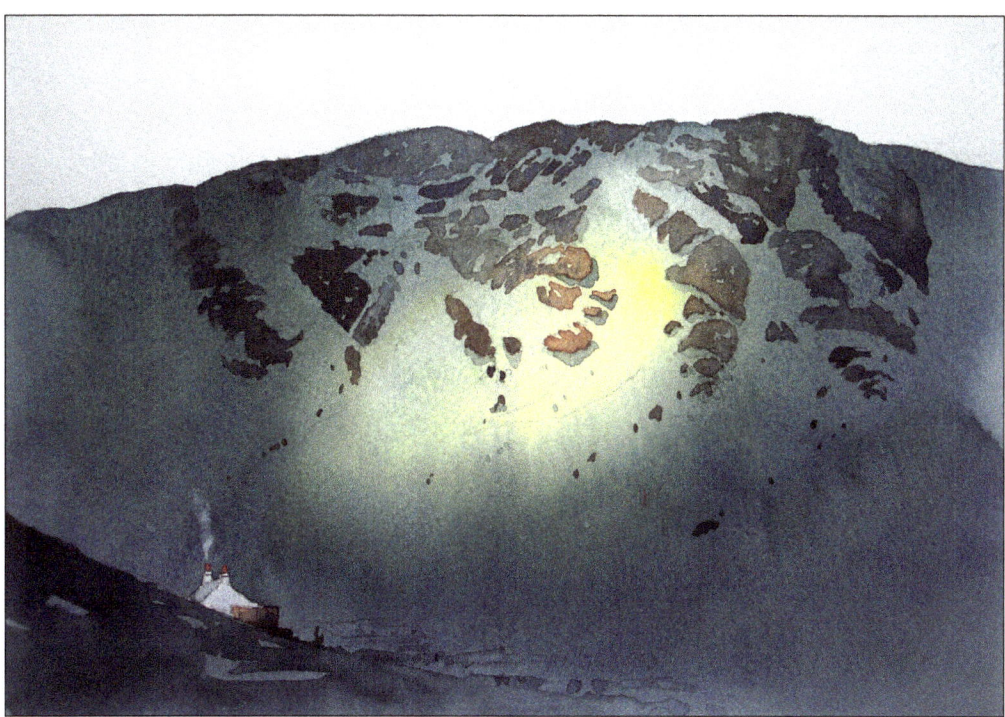

STAGE 3

4 minutes I darken the foreground with a loose mix of Payne's gray, lemon yellow, and French ultramarine. I create some shadows against the rocks in the light and add a few details around the cottage (see "Details" below). The overall result is striking because of the contrast of the warm light break that serves as an effective focal point for an otherwise dull landscape. .

Details

Adding Shadows Keep the direction of light in mind when adding shadows. For the rocks on the mountain, I imagine the light to come from above and slightly to the left, which casts a shadow downward and slightly to the right. To create the shadows, I glaze using French ultramarine and lemon yellow with a bit of Payne's gray.

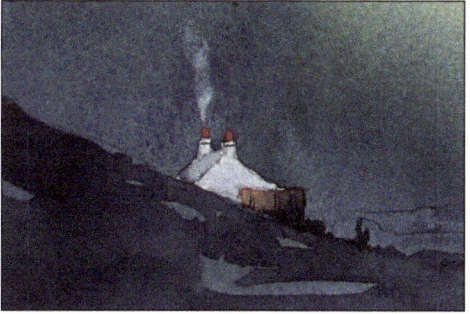

Painting the Cottage I paint the chimney pots with cadmium red; then I lift out some paint with a small damp brush to suggest the smoke. I paint the sides of the building using a pale wash of French ultramarine with a bit of burnt sienna; then I follow up with the roof at left using stronger washes of the same colors. Finally, I add the shed using burnt sienna and Payne's gray.

 22 Minutes

FILL THE SKY WITH ACTION

It often is an easy option to paint the sky with a simple flat or gradated wash, but what if you changed your approach and made the sky the most detailed part of the scene? As a general rule, I keep the sky simple if there is a lot of detail in the land portion of the composition—but if the land isn't very detailed, I try to introduce some tone, shape, and life into the sky. It's really all about balance, as you don't want to clutter your painting compositionally. Every once in awhile you'll find a sky that's exceptional, and you can make it the main focus of your painting, as I have done here. Plenty of action or movement in the sky means you don't need much landscape, which can be a savior for the artist with less than a half-hour to paint.

PALETTE
burnt sienna, cobalt blue, French ultramarine, Hooker's green, light red, raw sienna, and white gouache

EXTRA
hair dryer

STAGE 1

6 minutes I faintly draw the cloud shapes, horizon, and tide line with a pencil. Using the side of a medium round brush, I scrub in the blue portion of the sky with cobalt blue, leaving the edges around the clouds rough. Immediately afterward, I use a mix of French ultramarine and light red to similarly map in the cloud shadows. As I paint, I drop in a pale wash of raw sienna for the cloud shadows on the right and soften some areas with clean water. After using a hair dryer to dry the painting, I restore some of the darker cloud shadows by re-applying the mix of French ultramarine and light red.

STAGE 2

2 minutes For the water, I apply Hooker's green, French ultramarine, and raw sienna very loosely, letting them mix on the paper to suggest the varied colors in the sea. Then I wait for the wash to dry.

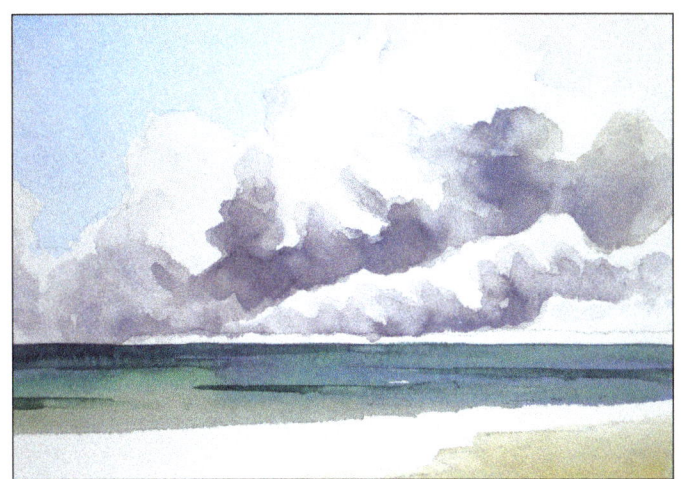

STAGE 3

4 minutes Next I apply layers of Hooker's green mixed with French ultramarine to paint one or two of the harder-edged wave shadows. For the beach in the foreground, I mix raw sienna with a bit of French ultramarine. All of these washes require very little accuracy, so I'm able to apply them freely and quickly.

STAGE 4

5 minutes Using a very small round brush loaded with a very dark mixture of French ultramarine and burnt sienna, I carefully lay in the rocks and the distant stretch of land below the clouds. Then I wet the beach area with clean water and apply the reflections of the strongest tones and the shapes of the clouds above. To do this, I simply use stronger mixes of the colors I used to form the clouds in stage 1. For the lighter reflections, I lift out paint with a damp brush.

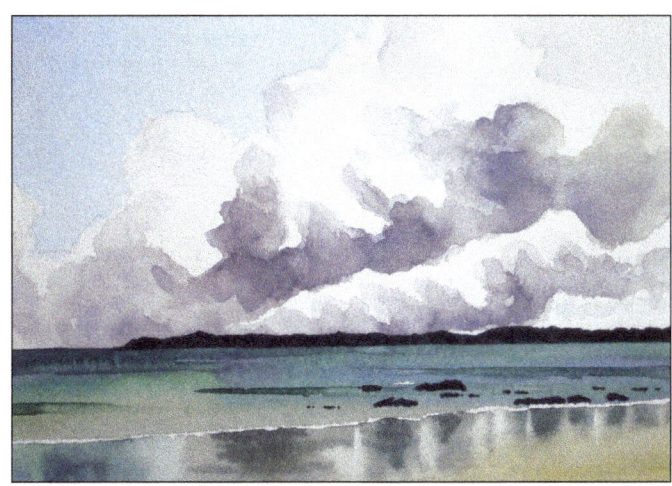

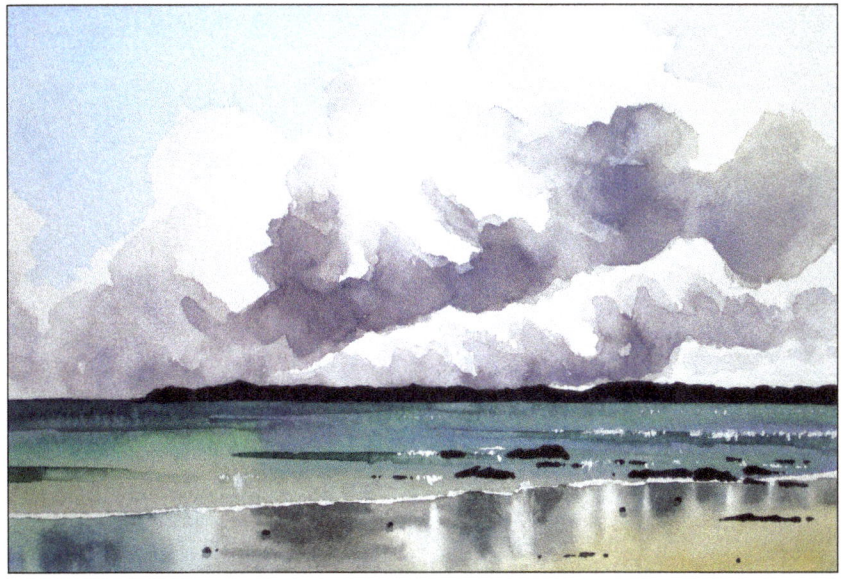

STAGE 5

5 minutes Once the foreground is dry, I add a few more dark rocks using French ultramarine and burnt sienna. Then I use a rigger brush loaded with white gouache straight from the tube to dab crests along the small ocean waves.

14 Minutes

WINTER SUNSET

Winter is my favorite time of year in terms of light and subject matter. The sun is much lower in the sky, which produces long, lazy shadows throughout the day, and the late-afternoon glow of the sun just before sunset is something no landscape painter should miss. I enjoy the barren landscapes of winter that hide all signs of greenery and growth, and when the snow arrives, I love how the landscape is transformed into a delightful source of contrast and simplicity. Due to the colder air, sunsets in winter are extremely clear, and I often take my sketchbook and camera to high ground for the perfect view. The best position is one that allows you to see both east and west—oranges and yellows in one direction, and reds, blues, and pinks in the other. This painting, which I completed in only 14 minutes, captures the setting winter sun after one of my excursions. The contrast of the dark, rocky foreground makes the light really shine.

PALETTE
burnt sienna,
cadmium red,
cadmium yellow, and
French ultramarine

EXTRAS
masking fluid,
an old brush,
and a hair dryer

STAGE 1

6 minutes On a sheet of watercolor paper, I use a pencil to create a border around my painting area (7" x 9") and outline the rocky foreground silhouette. I use an old brush to place a dot of masking fluid over the sun, and, once it dries, I use a large round brush to wet the paper with clean water to prepare for wet-into-wet action. I brush cadmium yellow around the sun, and as the wash radiates outward, I introduce a bit of cadmium red around the edges. While the initial washes are still wet, I apply a mix of French ultramarine and cadmium red to the top of the sky area, creating a gradated wash as I move down toward the cadmium red. I repeat this process below the sun in the bottom right-hand corner. I keep my strokes loose and avoid overblending the colors on the paper.

STAGE 2

5 minutes When the wash is completely dry, I brush in a stronger mix of French ultramarine and cadmium red across the top of the sky and work downward. As I bring it toward the sun, I add cadmium yellow to the mix and begin to break up the bottom of the cloud using horizontal strokes and the tip of a large round brush. Next I wet the horizontal band below the sun with clean water; then I brush on cadmium red, moving downward to a stronger mix of French ultramarine and cadmium red.

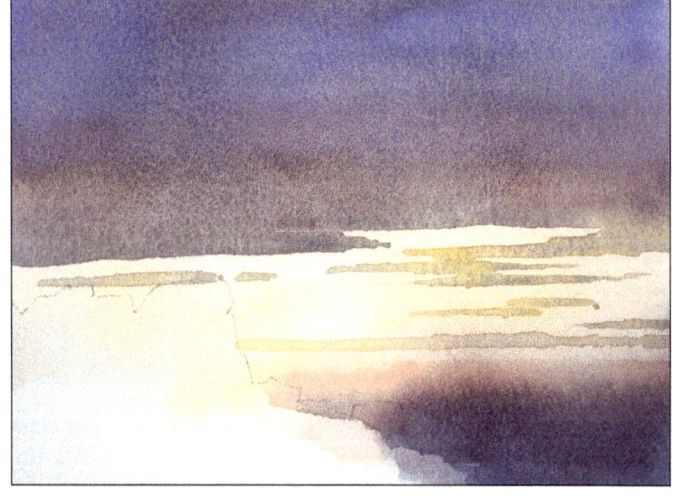

STAGE 3

3 minutes When the painting is dry, I use a damp bristle brush to scrub off some paint around the sun; then I follow up with the hair dryer. At this point, I remove the masking fluid from the sun. Then I complete the painting by adding the dark silhouette of the rocks using very strong washes of French ultramarine and burnt sienna, which I mix on the paper. Where the rocks are nearest the sun, I add cadmium red to suggest their warmth. Although the wash is very dark, the results of the loosely mixed colors are subtly visible, keeping the wash from looking too flat.

Details

Using Granulation For a simple composition like this, it's a good idea to use granulating colors for the sky to give the piece a bit of texture. Granulating colors, such as the French ultramarine shown above, consist of heavy pigments that settle into the tooth of the paper, creating a subtle, mottled appearance.

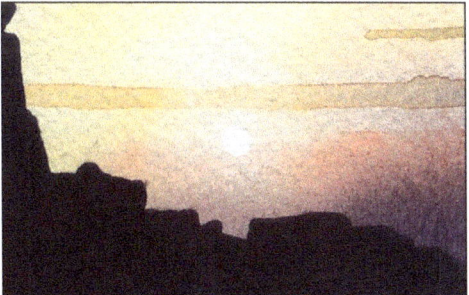

Touching Up with White Gouache Once you remove the masking fluid from the sun, you may want to touch up the edges with a bit of white gouache. This opaque paint is useful for recovering white in areas of the paper that have been painted accidentally or for adding white elements as an afterthought.

 33 Minutes

THE GOLDEN COLORS OF AUTUMN

Our senses are wonderful things. While looking through my photographs and sketches recently, I came across a number of my old studies of autumn. Although it was July when I rediscovered this work, I was immediately transported back to those moments I spent out in the woods painting the glorious browns and golds of the trees. In that passing moment of reminiscence, I could recall the smell of fallen leaves, the crunch of beech nuts under my feet, the taste of the rain, the warmth of the late afternoon sun, and the aromatic wood smoke from the chimney. Then, as quickly as it began, I was back to earth and looking at the sketchbook in my hands again. At that moment, I just had to paint autumn again.

PALETTE
burnt sienna,
French ultramarine,
Hooker's green,
lemon yellow,
light red,
Payne's gray,
and sap green

STAGE 1

7 minutes I draw the main shapes of the path and tree trunks on my watercolor paper. Then I begin painting with fluid, variegated washes (see page 6) to reflect the subtle color changes in the trees. Working from left to right, I apply Hooker's green mixed with French ultramarine followed by sap green and then lemon yellow, allowing the colors to blend where they meet. I repeat this process as I move across the background and down into the lower right corner, picking up colors and blending them into the previous wash. For the deeper, more neutral colors at left, I mix in a touch of Payne's gray.

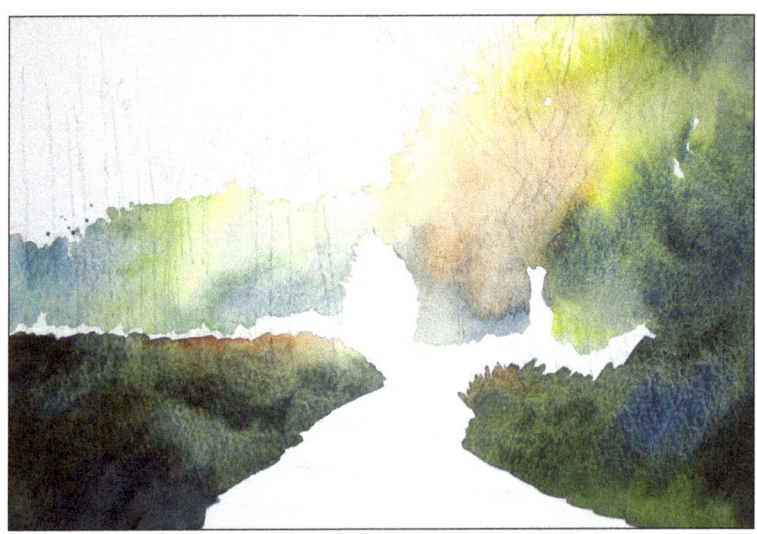

STAGE 2

5 minutes Next I tint the lighter parts of the ground using a very pale lemon yellow wash, adding burnt sienna in some areas. Then I paint the holly bush in the center of the scene with Hooker's green and French ultramarine, blending the colors on the paper. For the road, I use washes of light red and French ultramarine.

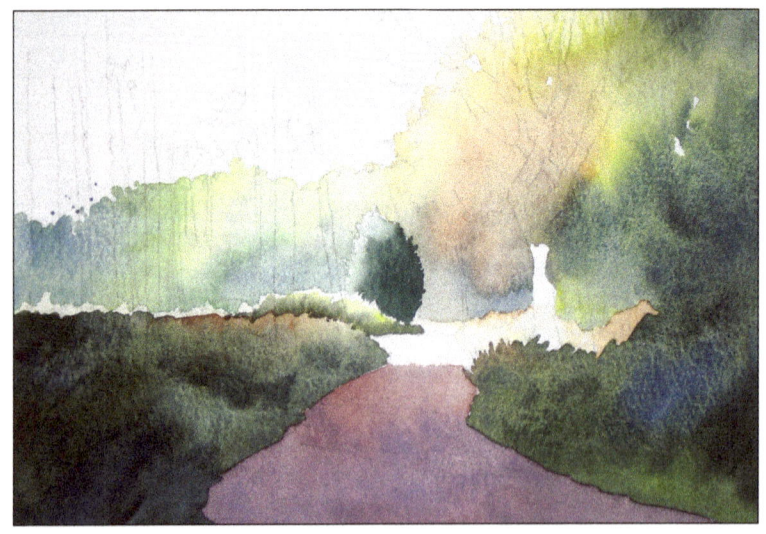

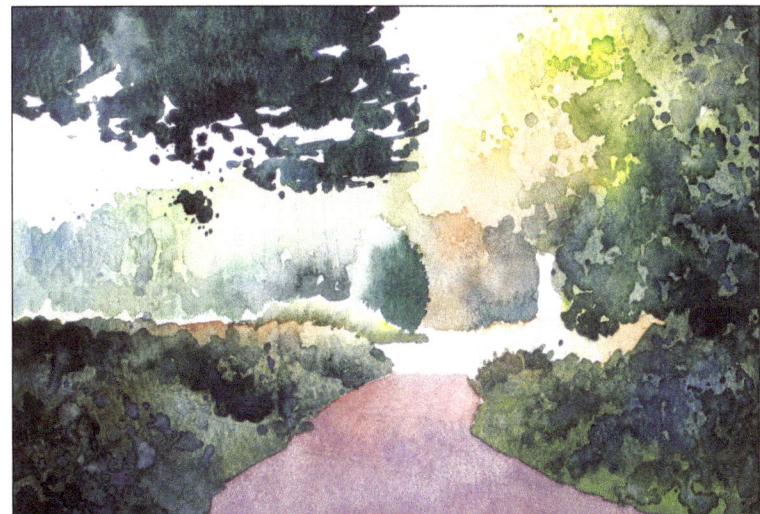

STAGE 3

9 minutes To create depth, I apply darker tones in the foliage. I add form to the background trees with burnt sienna, Hooker's green, and Payne's gray, using variegated washes. I spatter down the right-hand side of the painting with a medium round brush to suggest the mottled texture. I begin with sap green, move on to a mix of Hooker's green and French ultramarine, and then finish by moving up the paper with Payne's gray. I repeat this process in the foliage at left. I address the coniferous tree canopy on the left using a mix of Hooker's green, Payne's gray, and French ultramarine.

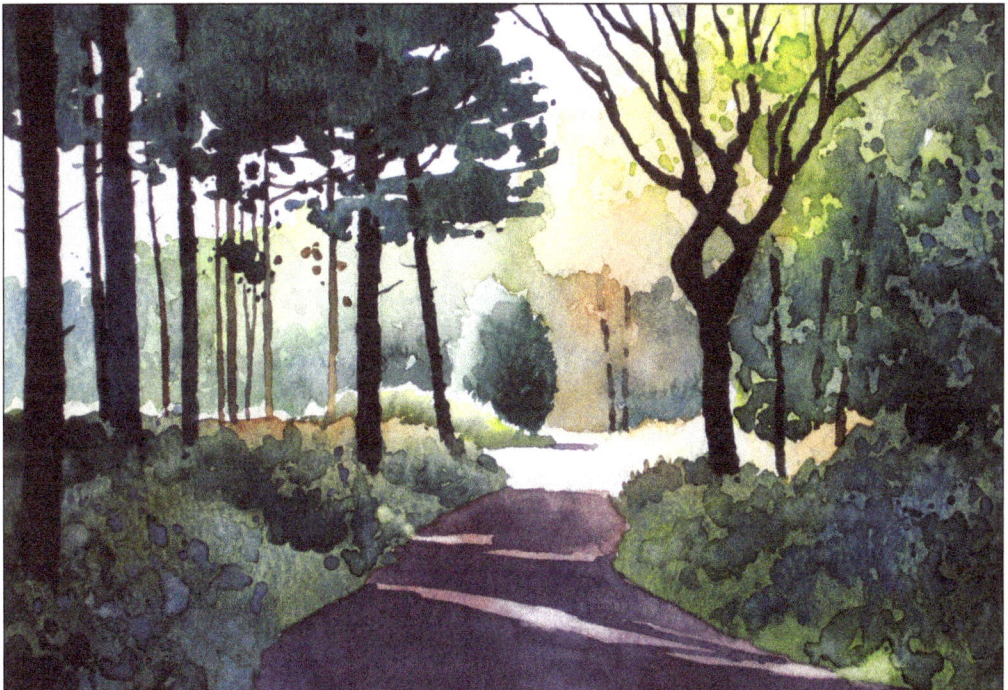

STAGE 4

9 minutes I finish the painting by applying the darkest darks and the cast shadows. I begin this stage by adding more tone to the holly bush with Hooker's green and French ultramarine. Then, using a strong wash of Payne's gray, I block in the solid shapes of the tree trunks. I indicate the cooler sections of the trunks by dropping in some French ultramarine, and I indicate the warmer sections with some burnt sienna. I add more tone to the distant holly bush, and then brush the cast shadows across the foreground with a mix of French ultramarine and light red. I am careful to leave areas of the initial wash showing through. To finish, I create spots of light in the foliage by lifting out paint with a dampened brush.

- *When applying a variegated wash, make sure the values of each color you are using remain the same throughout the area you are painting.*

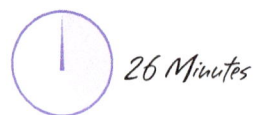 *26 Minutes*

RAINY DAYS

Rain can be a joy to paint if you include the appropriate elements in the composition. A painting of a downpour over distant hills with nothing else in the scene would make a dull subject. But when you add elements to the composition, be careful not to detract too much attention from the sky. It's a good idea to pair a rainy sky with a simple, subdued subject. To liven up the composition, use reflections to their full advantage, whether in foreground puddles, on a road, or on the roof of a building. The contrast of the "shine" and crisp lines of the reflections are the perfect complement to a moody sky—they can be as refreshing as the downpour itself!

PALETTE
burnt sienna,
cobalt blue,
Hooker's green, light red,
Payne's gray,
and raw sienna

STAGE 1

6 minutes After drawing the simple scene on my watercolor paper, I begin with a wet-into-wet wash for the rainy sky. First I wet the entire scene, except for the barn roof, and then use cobalt blue and light red to paint the sky. I add Payne's gray to the mix for the darker, more neutral areas. While the paint is still wet on the paper, I tilt the board to a steep angle and let it settle to form fine veils of rain.

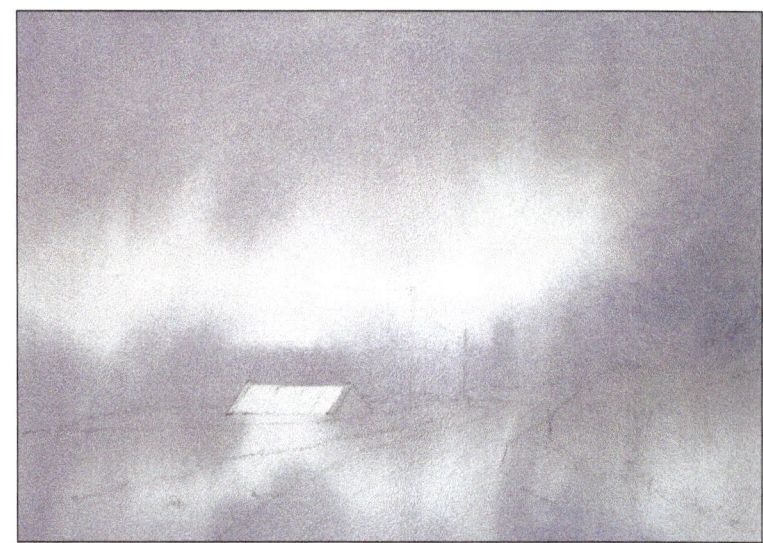

STAGE 2

4 minutes When the wash is completely dry, I address the land. I begin in the distance with Hooker's green mixed with cobalt blue and a touch of light red. I keep this wash pale to suggest the thick, damp atmosphere. As I progress toward the foreground with the wash, I create a variegated wash of Hooker's green, raw sienna, and Payne's gray. Then I strengthen the colors toward the foreground to create the illusion of distance in the scene.

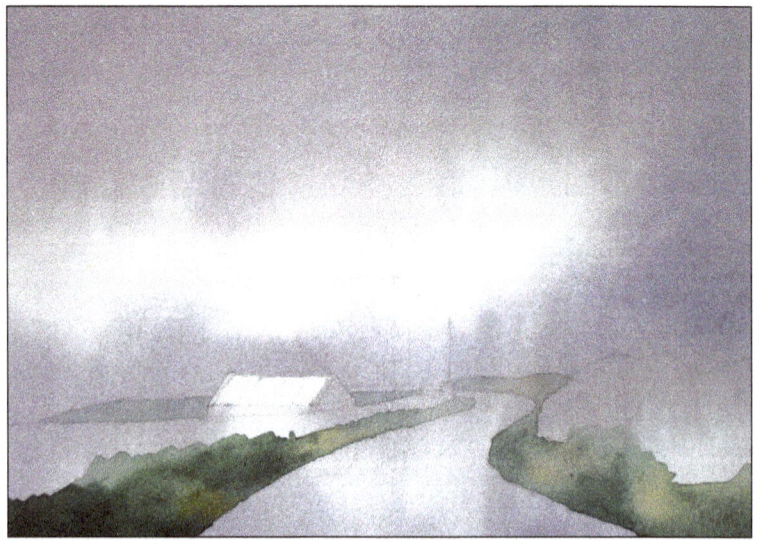

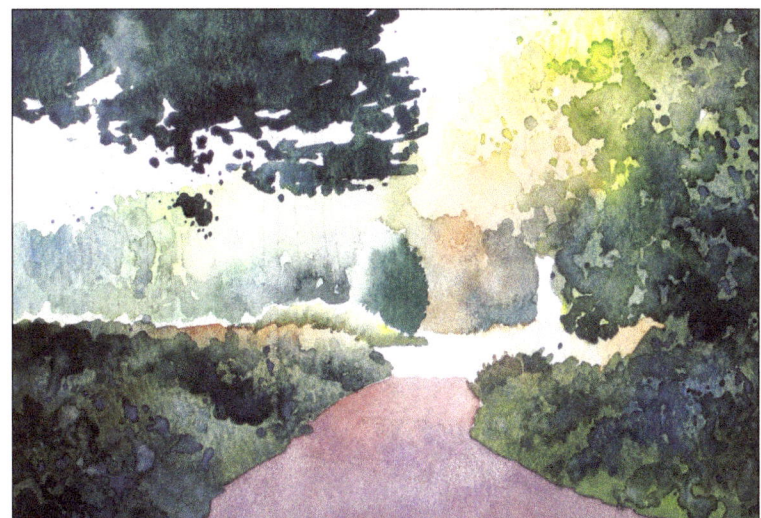

STAGE 3

9 minutes To create depth, I apply darker tones in the foliage. I add form to the background trees with burnt sienna, Hooker's green, and Payne's gray, using variegated washes. I spatter down the right-hand side of the painting with a medium round brush to suggest the mottled texture. I begin with sap green, move on to a mix of Hooker's green and French ultramarine, and then finish by moving up the paper with Payne's gray. I repeat this process in the foliage at left. I address the coniferous tree canopy on the left using a mix of Hooker's green, Payne's gray, and French ultramarine.

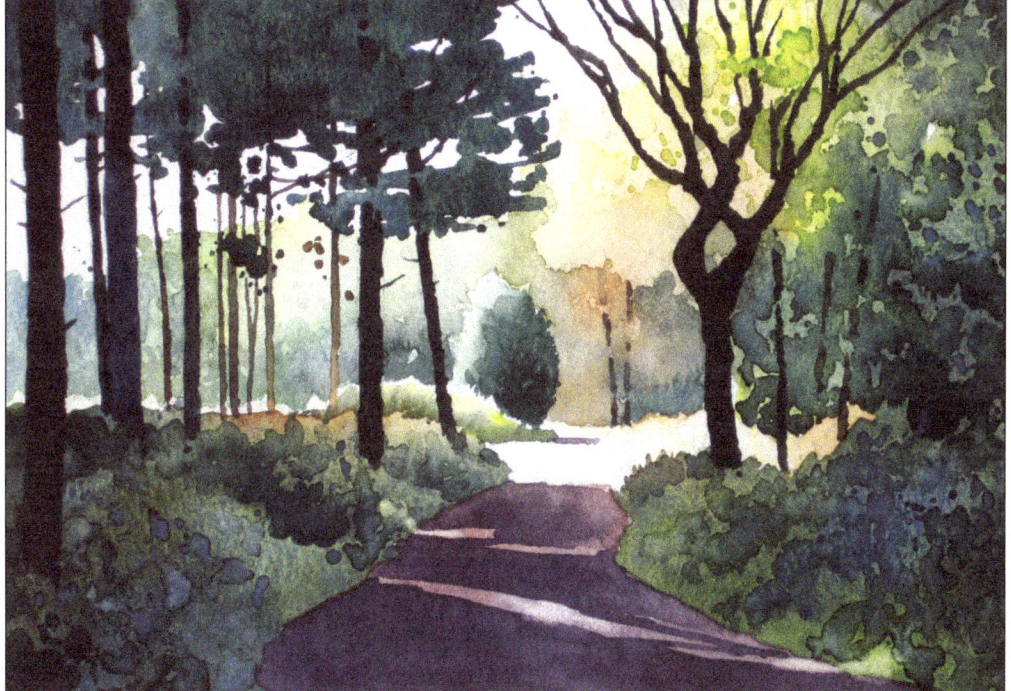

STAGE 4

9 minutes I finish the painting by applying the darkest darks and the cast shadows. I begin this stage by adding more tone to the holly bush with Hooker's green and French ultramarine. Then, using a strong wash of Payne's gray, I block in the solid shapes of the tree trunks. I indicate the cooler sections of the trunks by dropping in some French ultramarine, and I indicate the warmer sections with some burnt sienna. I add more tone to the distant holly bush, and then brush the cast shadows across the foreground with a mix of French ultramarine and light red. I am careful to leave areas of the initial wash showing through. To finish, I create spots of light in the foliage by lifting out paint with a dampened brush.

- *When applying a variegated wash, make sure the values of each color you are using remain the same throughout the area you are painting.*

 26 Minutes

RAINY DAYS

Rain can be a joy to paint if you include the appropriate elements in the composition. A painting of a downpour over distant hills with nothing else in the scene would make a dull subject. But when you add elements to the composition, be careful not to detract too much attention from the sky. It's a good idea to pair a rainy sky with a simple, subdued subject. To liven up the composition, use reflections to their full advantage, whether in foreground puddles, on a road, or on the roof of a building. The contrast of the "shine" and crisp lines of the reflections are the perfect complement to a moody sky—they can be as refreshing as the downpour itself!

PALETTE
burnt sienna,
cobalt blue,
Hooker's green, light red,
Payne's gray,
and raw sienna

STAGE 1

6 minutes After drawing the simple scene on my watercolor paper, I begin with a wet-into-wet wash for the rainy sky. First I wet the entire scene, except for the barn roof, and then use cobalt blue and light red to paint the sky. I add Payne's gray to the mix for the darker, more neutral areas. While the paint is still wet on the paper, I tilt the board to a steep angle and let it settle to form fine veils of rain.

STAGE 2

4 minutes When the wash is completely dry, I address the land. I begin in the distance with Hooker's green mixed with cobalt blue and a touch of light red. I keep this wash pale to suggest the thick, damp atmosphere. As I progress toward the foreground with the wash, I create a variegated wash of Hooker's green, raw sienna, and Payne's gray. Then I strengthen the colors toward the foreground to create the illusion of distance in the scene.

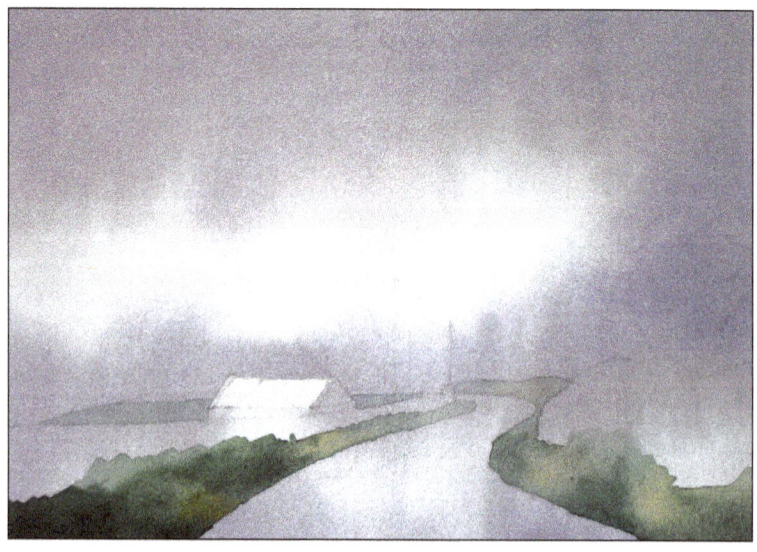

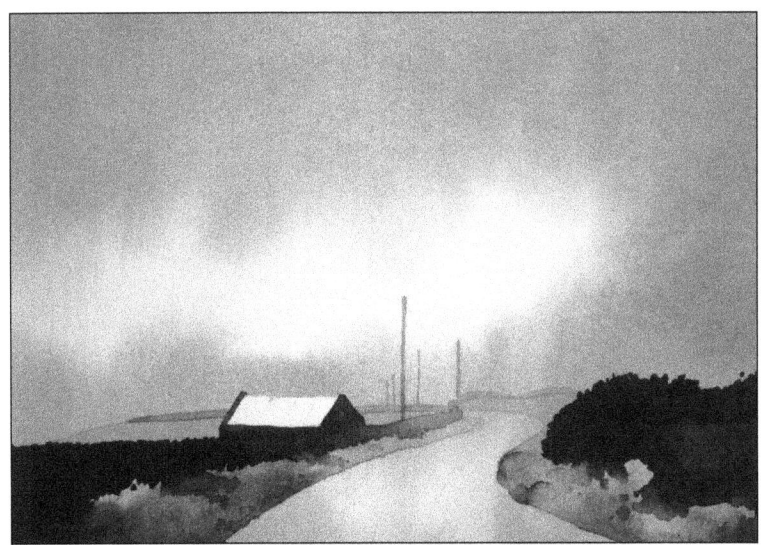

STAGE 3

9 minutes Next I paint the dark wall, telephone poles, building, and the bushes on the right. For the wall, I begin in the distance using a very pale mix of burnt sienna and cobalt blue, gradating this into a stronger mix of Payne's gray and burnt sienna toward the foreground. As I paint the wall, I add the poles and building using a small, round brush, matching the gradation of the wall as I move left. Then I paint the bushes with Hooker's green and Payne's gray. To soften the wall and bushes so they merge with the ground, I stroke along the bottom of the wash with a clean, damp brush.

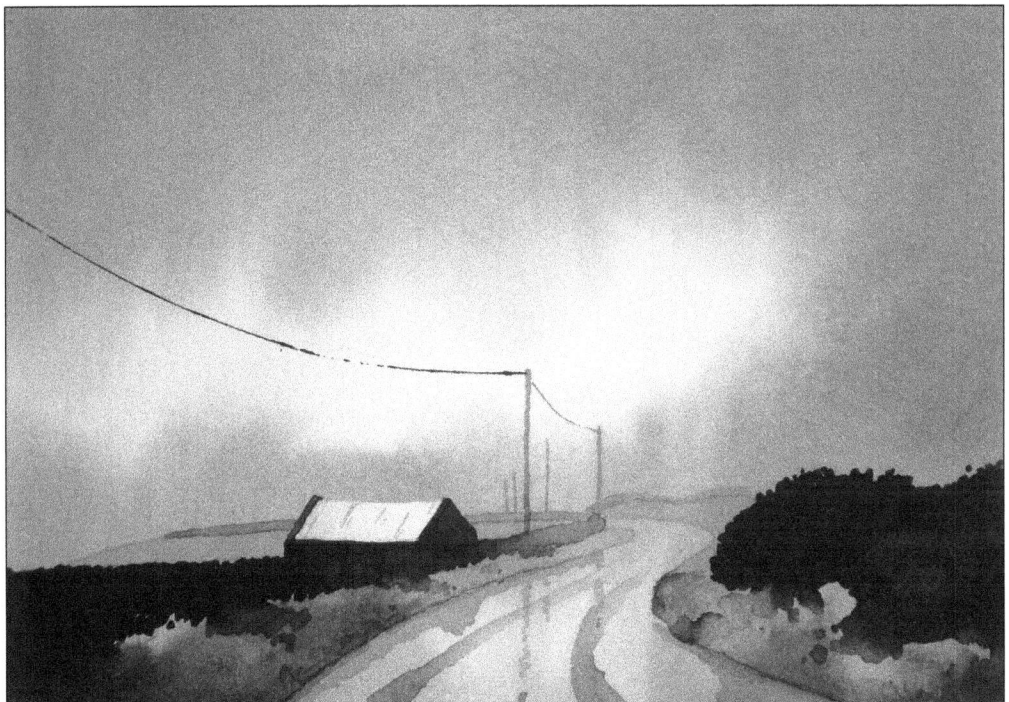

STAGE 4

7 minutes With a mix of cobalt blue and light red, I paint the reflections on the road and begin adding stonework details on the wall. I build up tone in the bushes nearest the viewer using Hooker's green and Payne's gray. To add the long, thin telephone wire, I brush Payne's gray onto the edge of a piece of scrap paper. Then I hold the scrap paper perpendicular to my painting, curve the edge, and "stamp" the line onto the painting, making sure it touches the top of the telephone pole. This gives me a natural curve. I finish by painting tire tracks on the road on top of the dried reflections using a mix of Payne's gray, cobalt blue, and light red. This leads the eye into the scene and prevents the road from looking like a river.

- *When painting rain, brush the wet-into-wet colors over the entire scene to avoid creating harsh edges.*
- *Rain reflects grays, so neutralize your colors with a tube gray such as Payne's gray before using them in the scene.*

 25 Minutes

THE IMPORTANCE OF CAST SHADOWS

Cast shadows and other effects of bright sunlight really can make all the difference in a painting. A dull day without much light offers little in the way of brilliance to a scene, as flat light often can wash out a subject. But bright light will not only enliven your subject matter—it also will highlight new subjects within the scene. On many occasions, especially on breezy days with intermittent light breaks, I've noticed how an ordinary scene in front of me can suddenly turn into an exciting subject full of tone, contrast, and cast shadows with just a brief emergence of the sun. On days like this, it's worth waiting those few extra moments with your camera until the light is just right. Although you shouldn't rule out other compositions, I find the most dynamic lighting setup is to have the sun positioned to one side, throwing long shadows across the scene. Notice how this particular scene doesn't become interesting until I drape shadows across the path.

PALETTE
burnt sienna,
French ultramarine,
lemon yellow,
light red,
Payne's gray,
raw sienna,
and sap green

EXTRA
hair dryer

STAGE 1

3 minutes I draw the main shapes of the trees and indicate the road with a 4B pencil; then I paint the mass of trees with a loose, variegated approach. Starting on the left, I use sap green, then lemon yellow, and then French ultramarine as I work my way across the scene, mixing the colors on the paper as I progress. The holly bush on the far right is much darker in value than the rest of the scene, so I paint it with a strong mix of French ultramarine, Payne's gray, and sap green.

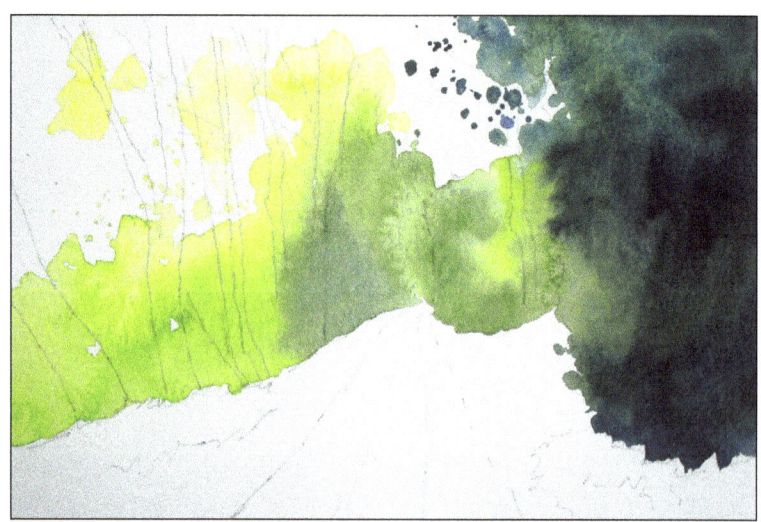

STAGE 2

4 minutes I allow the initial washes to dry. Then, to give the trees some texture, I spatter them with the same colors—sap green and lemon yellow on the left, moving to French ultramarine, Payne's gray, and sap green on the right. I soften some of the spatter with clean water as I paint.

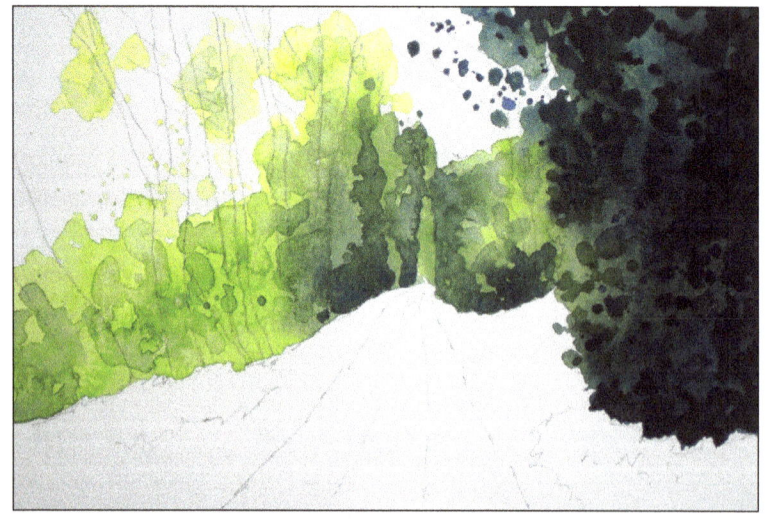

STAGE 3

14 minutes When the previous stage is dry, I address the tree trunks. Using a very small round brush and a strong mix of Payne's gray and raw sienna (with sap green here and there), I stroke in the trunks and branches, painting around foliage clusters that overlap them. I use variegated washes to add the initial colors for the ground. For the patches of greenery, I use sap green and French ultramarine; along the edges of the road, I use burnt sienna and French ultramarine. For the road, I use pale raw sienna, adding burnt sienna near the foreground. Between each wash, I use a hair dryer to speed up the drying process.

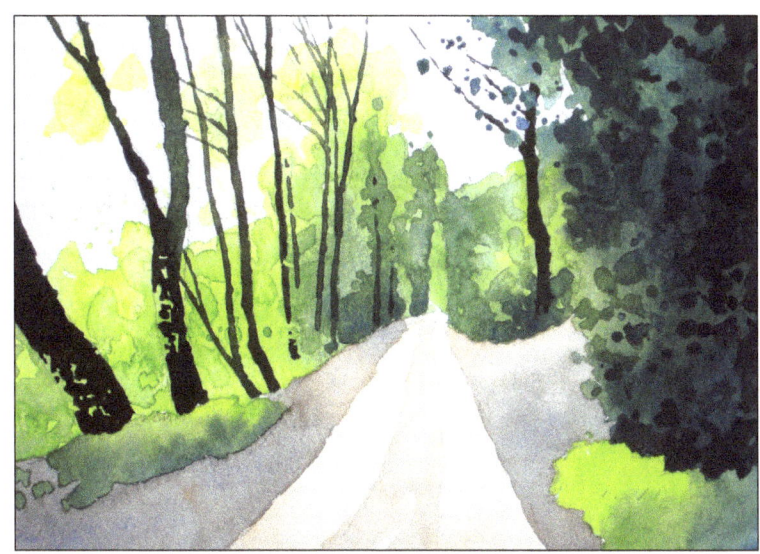

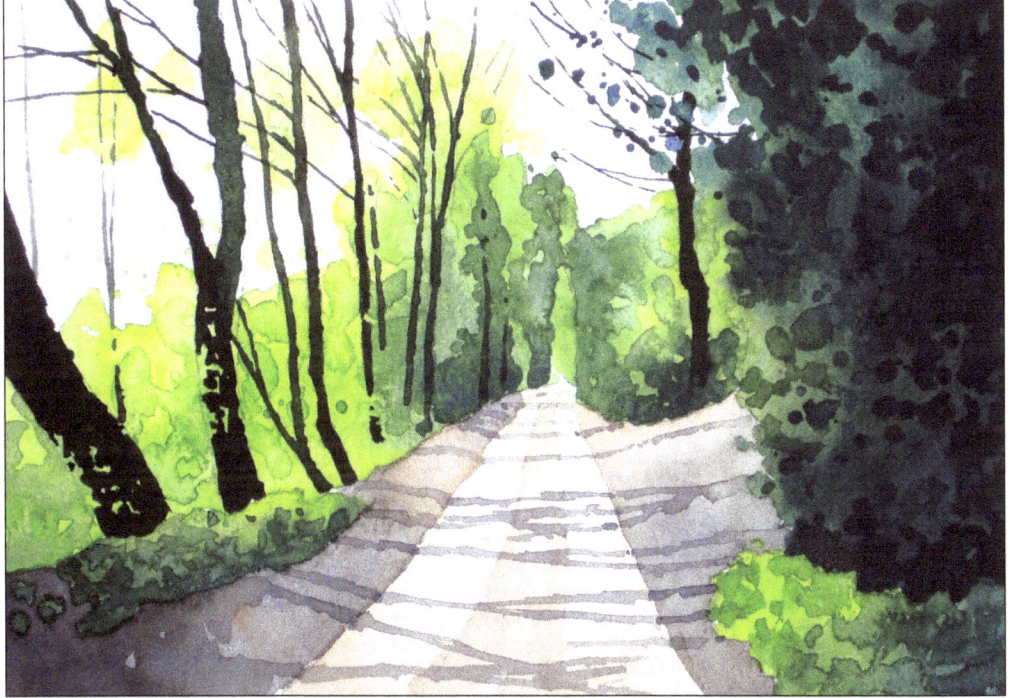

STAGE 4

4 minutes Finally, I bring the scene to life by adding the shadows. I mix raw sienna, French ultramarine, and light red for the shadows on the road, and I continue them across the edges with a mix of French ultramarine and burnt sienna. I use this same mix to darken the bottom left-hand corner. I add some texture to the foliage by spattering with sap green and French ultramarine. To finish, I add a few finer twigs with a rigger brush using a mix of Payne's gray and raw sienna.

 30 Minutes

USING WHITE

Because the paper serves as "white" in watercolor painting, white paint isn't necessary—but it does come in handy now and again. From time to time, I use opaque white paint to restore a missed highlight or even to spatter snow over a scene. Called "Chinese white," "opaque white," or "white gouache," this water-based paint is opaque and will show up on top of darker paint. For this reason, it is best to apply it over dry washes at the end of a painting session, as it will create odd blends and tones if mixed with other colors.

PALETTE
cadmium red, cobalt blue, Hooker's green, Naples yellow, Payne's gray, raw sienna, violet, and white gouache

EXTRAS
masking fluid, an old brush, and a hair dryer

STAGE 1

7 minutes I sketch the scene in pencil and immediately mask the two figures with liquid frisket. As soon as the mask is dry, I apply a very diluted wash of Naples yellow over the sky area and pull it into the trees. While this is still wet, I brush in cobalt blue. Then, with increasing strengths of paint, I build up the line of trees wet into wet with a loose mix of intense violet and Hooker's green. I allow the wash flat to dry naturally on a flat surface.

STAGE 2

9 minutes I wet the foreground area with clear water and brush in a heavily diluted wash of cobalt blue mixed with a hint of Naples yellow to suggest the soft shadow areas on the road. I dry this quickly with a hair dryer and then apply raw sienna and Payne's gray to the land shapes at the sides of the road using a small round brush. I am careful to leave gaps of white paper to indicate the snow.

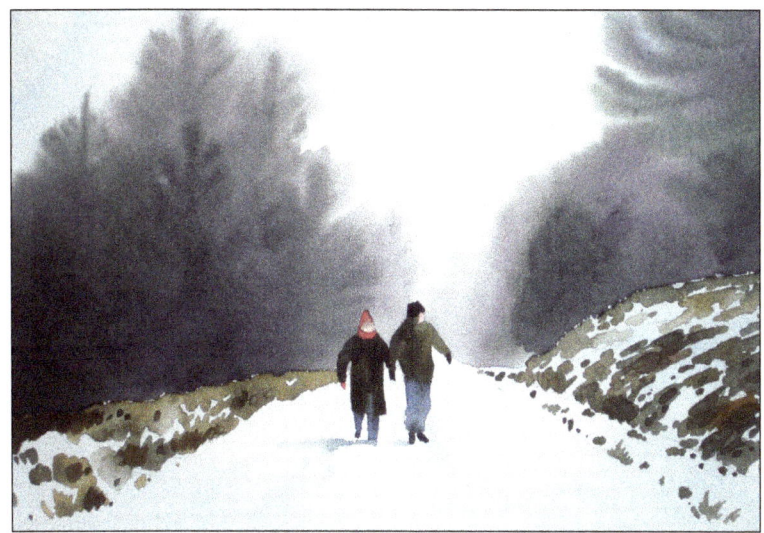

STAGE 3

8 minutes I remove the mask from the figures and paint their clothing with strong washes of cobalt blue, raw sienna, and Payne's gray. Next, using Payne's gray, I add a quick shadow with a mix of cobalt blue and Payne's gray to anchor the figures to the ground; I also add a few darker accents to the land shapes with Payne's gray and raw sienna. Then I paint the red hat, scarf, and glove with cadmium red, and I dry the painting completely with the hair dryer.

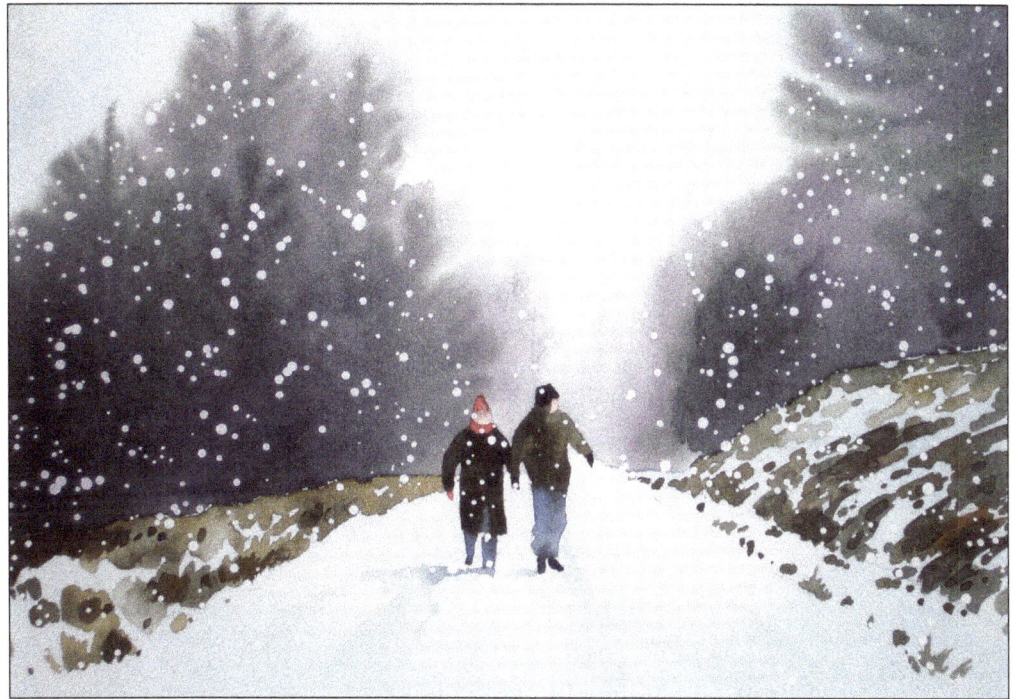

STAGE 4

6 minutes Finally, I lay the painting flat on the table so I can create the white snowflakes. I load a medium round brush with white gouache and, holding the brush about two feet above the painting, gently tap the handle to spatter the opaque paint over the entire scene. The random spattering of white dots is ideal for suggesting falling snow.

- *Include plenty of dark tones throughout the painting to effectively contrast with the white snowflakes.*
- *When using white gouache to add highlights, dilute it no thinner than the consistency of cream—otherwise it may not show up against the darker washes.*

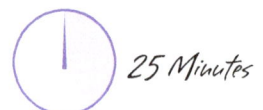 *25 Minutes*

SUMMER TREES

Summer trees painted in flat washes of a single color often can look "cut out" and lifeless. One fellow painter in a group of mine once quipped that his trees looked a bit wooden. Joking aside, a good way to liven up your summer trees is to mix loose washes on the paper as you paint, rather than mix your colors solidly in a mixing well or on a palette. I recommend using a tube green as a base color and then warming it by touching in yellows or cooling it by touching in blues. By using this fluid approach, it's possible to work the colors together to create lovely variegated washes. You must keep recharging your brush as soon as it loses moisture to maintain soft blends of color. As you create this wash, simply record the strongest changes in color and tone within the scene—the details will come later.

PALETTE
burnt sienna,
cobalt blue,
French ultramarine,
lemon yellow, light red,
Payne's gray,
raw sienna,
and sap green

PALETTE
hair dryer

STAGE 1

6 minutes After drawing the scene, I quickly lay in the sky using a pale wash of cobalt blue. I boost the drying time with a hair dryer; then I move on to the mass of greenery. I use sap green as a base color and touch in lemon yellow for warmer, brighter greens; for the cooler areas, I touch in French ultramarine. Where the values are darker, I apply stronger washes. I introduce some raw sienna into the foreground area of the wash. The whole mass of greenery is allowed to blend on the paper. All shapes, details, and value separations will be picked out of this initial wash.

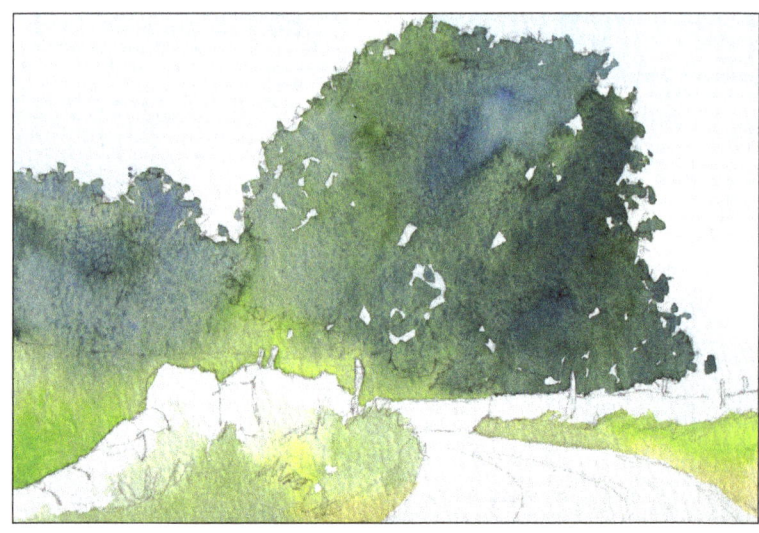

STAGE 2

7 minutes Next I overlay washes to separate the shapes of the trees. For this I use a shadowy green, mixed from French ultramarine and sap green. I fluidly stipple (see page 7) this mixture onto the trees to suggest the loose masses of textured foliage. I apply some of the same color to the edges of the grassy areas, and then I paint the distant wall with French ultramarine and burnt sienna. Notice how the initial variegated wash shows through and creates interest within the trees.

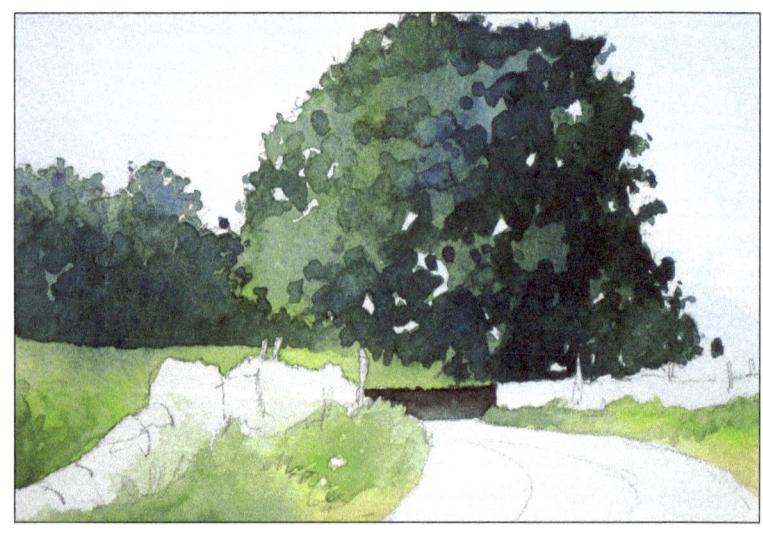

STAGE 3

5 minutes Using pale washes of French ultramarine and burnt sienna, I apply the varied colors of the walls. For the road, I use washes of French ultramarine and light red.

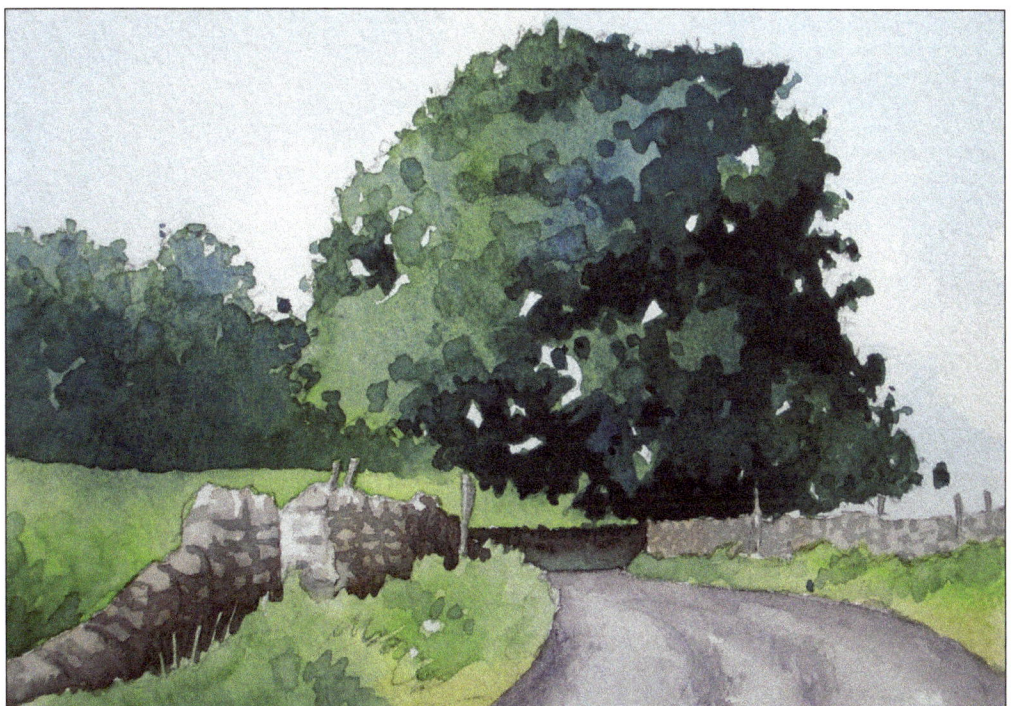

STAGE 4

7 minutes I return to the main tree to apply the darkest tones with French ultramarine and sap green; then I add Payne's gray to neutralize the color and give it body and strength. I suggest a bit more grass and then detail the wall with French ultramarine and burnt sienna using the tip of a small round brush. I finish the painting by darkening areas of the road with a bit of scumbling (see page 6).

 30 Minutes

WINTER TREES

Painting the leafless branches of a winter tree in only 30 minutes is an excellent exercise. Leafless trees offer a simplified version of the general structure of trees seen in all seasons, and they stand as a good test of your hand-eye coordination as they're perfect for improving your brush control. To avoid stylizing the trees, don't think about what types of trees they are. Instead, think of them as chunky, slender, elegant, short, tall, and so on; then simply draw the forms and shapes with the brush. As you paint, keep your strokes loose and spontaneous; the looser your hand, the more variation and character will show up in each stroke. And remember that you don't have to copy each branch exactly as it appears—you're free to tidy up your tree by eliminating some of the wayward twigs and branches.

PALETTE
burnt umber, cobalt blue, French ultramarine, light red, raw sienna, and sap green

STAGE 1

7 minutes After sketching the composition, I loosely wash in the upper sky area with cobalt blue and a large round brush. I follow up with a light mix of cobalt blue and light red for the gentle shadows within the clouds. Then I work on the distant land using variegated washes of raw sienna and light red. In the immediate foreground, I use burnt umber for the color of the winter reeds and sap green for the grassy area on the left.

STAGE 2

4 minutes Now I add some form and depth to the land. First I mix light red with a touch of cobalt blue to deepen the distant moor, and then I use slightly stronger mixes of burnt umber and cobalt blue for the foreground grasses. I also use a mix of raw sienna and French ultramarine on the left where the grasses are in shadow.

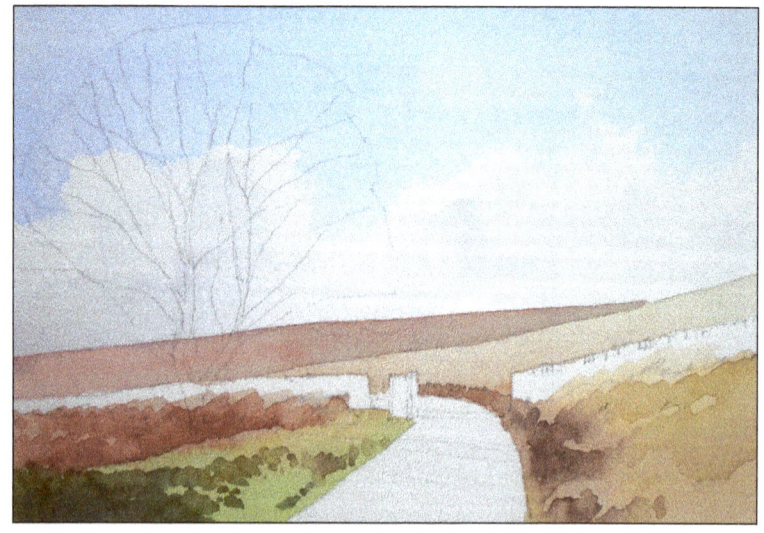

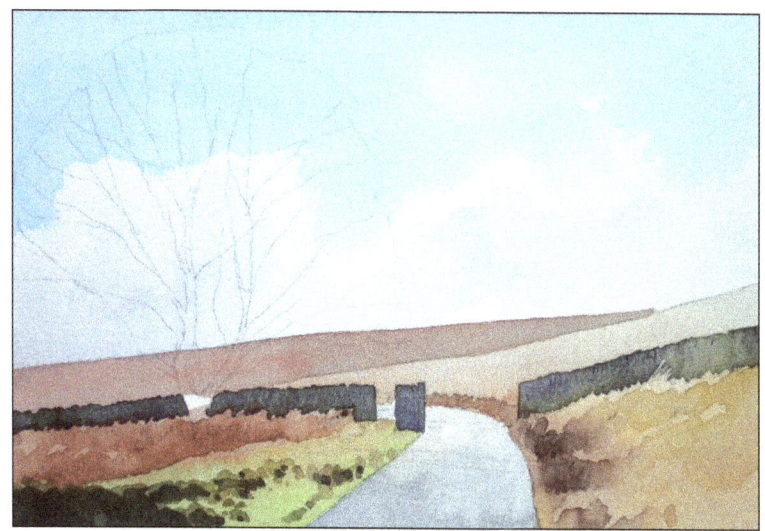

STAGE 3

5 minutes I use a mix of French ultramarine and burnt umber to paint the wall, using the wet-into-wet technique to add some sap green here and there. Then I work on some of the darker details in the foreground, applying a pale mix of French ultramarine and burnt umber on the road.

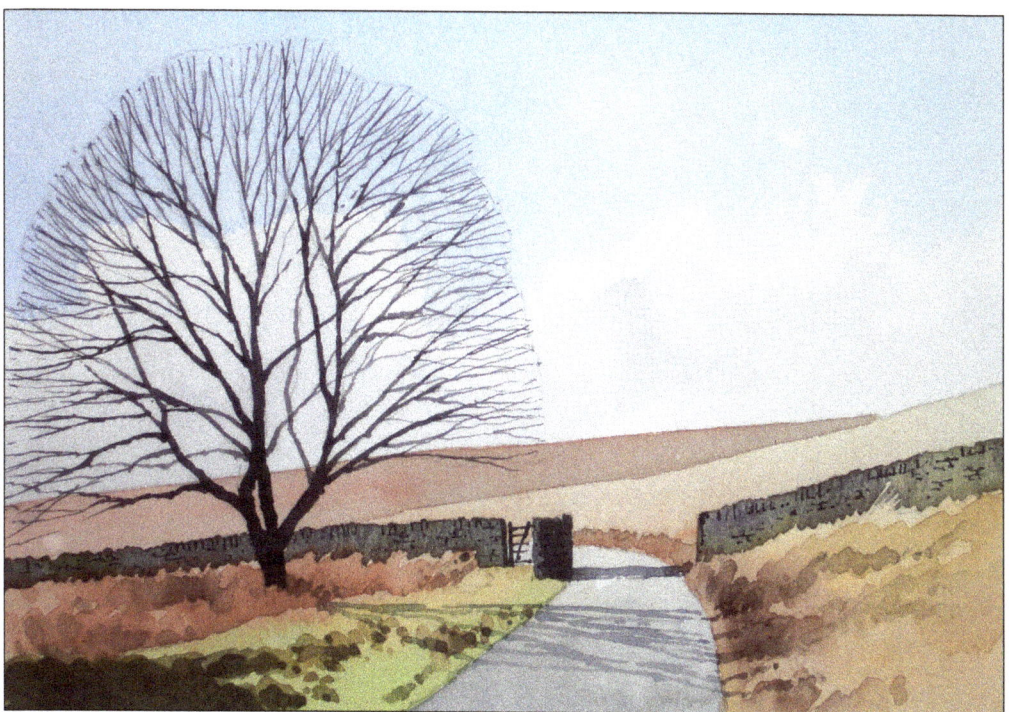

STAGE 4

14 minutes I finish the painting with a strong, dark mix of French ultramarine and burnt umber for the winter tree. When painting a leafless tree, I first draw its general shape in pencil to create a guide for painting, making sure I indicate all of the main branches. Then I work from the trunk outward using a very small round brush, creating the first two-thirds of the branches' length. At this point, I switch to a rigger brush and finish the finer branches and twigs. With the tree completed, I use the same dark tree wash to add details on the wall; then I dilute the wash and paint the tree's cast shadow on the ground and across the road.

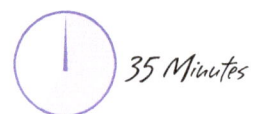
35 Minutes

PAINTING BUILDINGS

Buildings present many challenges to the watercolor artist. First, how on earth do you get the stonework to look natural with all that detail? How do you make the building look three-dimensional and solid? And if that's not enough, how do you address the perspective? It's best to practice on one aspect at a time. In this lesson, focus only on the amount of detail you should apply. You'll be surprised at how little detail is actually required when you take advantage of variegated washes—remember that the eye needs only a suggestion of detail to fill in the rest!

PALETTE
cobalt blue, Hooker's green, light red, Payne's gray, raw sienna, and sap green

STAGE 1

5 minutes After carefully drawing the buildings, I simplify the background mass of trees by applying strong, fluid washes of light red, Payne's gray, and raw sienna, mixing them loosely on the paper. The mid-to-dark tonal strength of this wash contrasts with the slightly paler buildings and gives the composition an immediate sense of depth. While the wash is settling, I apply weak washes of cobalt blue and Payne's gray on the road.

STAGE 2

10 minutes Next I apply variegated washes in the remaining areas of the painting (except those that are to be left white). These initial washes are the most important parts of the painting, as they provide interest, detail, color, and tone through all subsequent washes. I use raw sienna, Payne's gray, cobalt blue, and sap green to wash over the stonework; sap green and raw sienna for the areas of grass; and Hooker's green plus cobalt blue for the shed door. I allow the washes to dry.

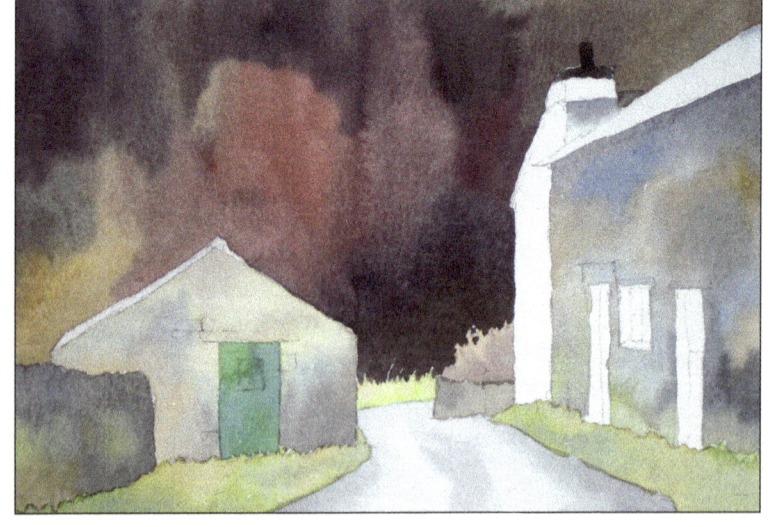

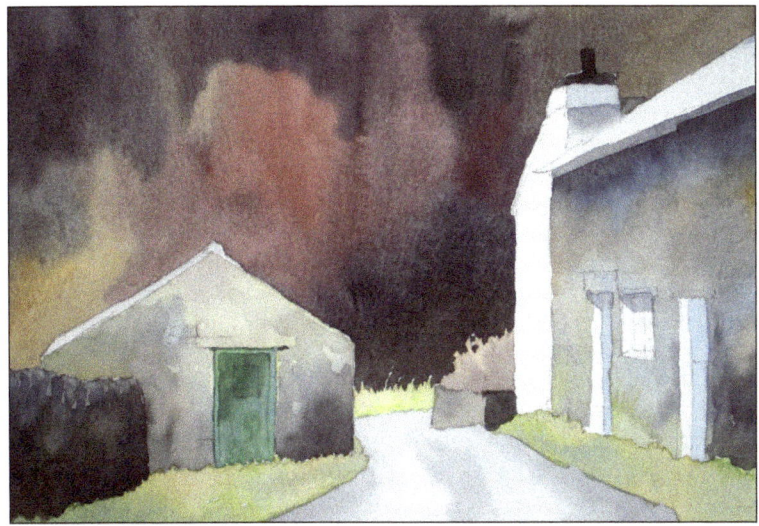

STAGE 3

7 minutes For the next layers in the sequence, I build up the shadows by adding Payne's gray to the initial wash colors. For example, I mix Payne's gray with Hooker's green and cobalt blue for the shadow on the shed door, and I add more Payne's gray to the raw sienna, Payne's gray, cobalt blue, sap green wash for the shadows on the stonework.

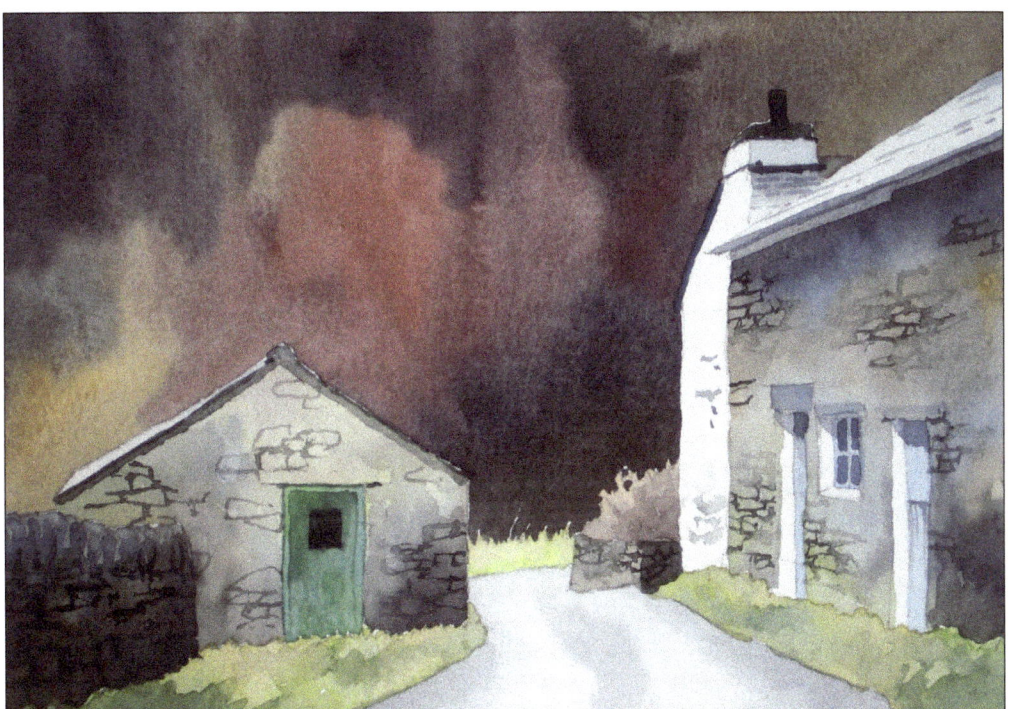

STAGE 4

13 minutes Finally, I work on the darks of the painting. Using the tip of a very small brush, I sketch patches of stonework with a mix of Payne's gray and raw sienna. I work on one area at a time, adding the details very quickly and then immediately softening the edges here and there with clean water. Notice how the initial wash, the shadow layer, and the finer strokes produce the illusion of detail.

 28 Minutes

SUMMER SHOWERS

Rain is a special event at the height of summer when the morning has been hot and still, and you can almost feel the atmosphere gradually building throughout the day. By late afternoon, the sky can hold out no more and down comes a steady summer shower. I have been caught out in many of these—one in particular was a rather violent thunderstorm. I took cover in a bus shelter and watched in amazement as a bolt of lightning struck a power transformer just yards away from me. Exciting indeed, but it's the passing of the shower that holds the most delight. The rain intensifies color (a bit like putting a painting behind glass), and any resulting puddles of water often add a little extra interest to a painting.

PALETTE
French ultramarine, Payne's gray, raw sienna, and sap green

EXTRA
hair dryer

STAGE 1

8 minutes After sketching the scene on my watercolor paper, I begin painting the distant hill and the field at left with sap green and raw sienna. I dry this application with a hair dryer and continue adding loose washes of sap green, French ultramarine, raw sienna, and Payne's gray for the general colors and tones of the foliage, letting the colors mix on the paper. Along the edges of the trees, I spatter on the same colors to suggest thinning leaves.

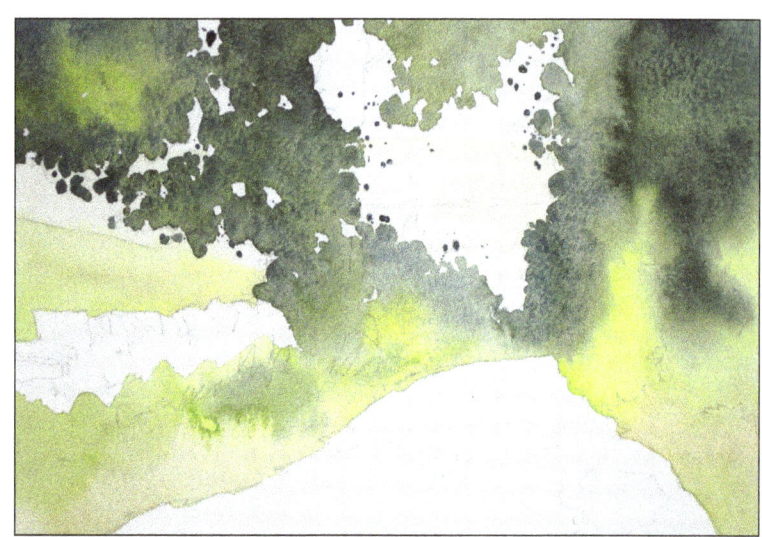

STAGE 2

8 minutes When the painting is dry, I work back into the foliage with the spattering technique, producing a mottled texture and a darker tone. I use sap green mixed with French ultramarine for most of this stage, adding Payne's gray to the mixture for the darker sections in the upper areas.

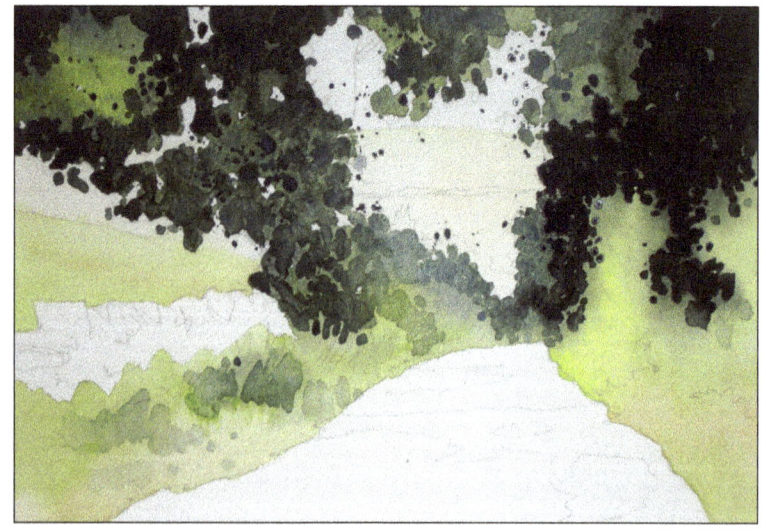

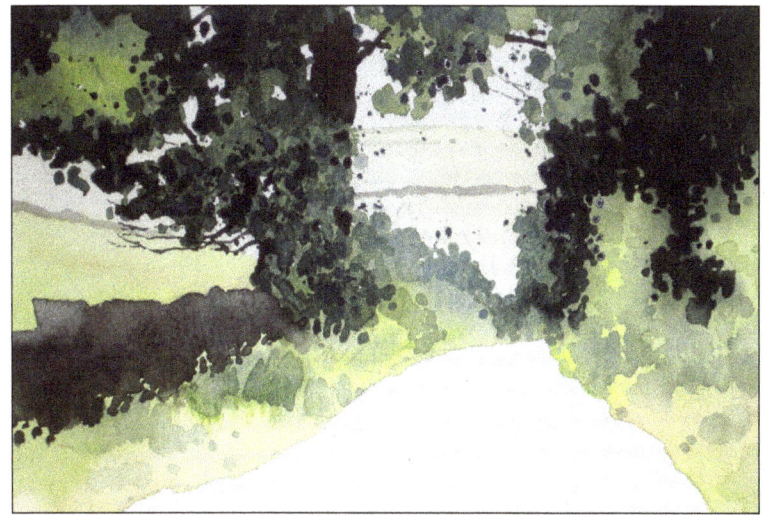

STAGE 3

6 minutes I finalize the trees with a bit more spattering. I use the tip of a small round brush and a strong mix of Payne's gray and raw sienna to paint the tree trunk and a few branches. Then I dilute the mix a bit and block in the wall. Adding even more water to the mix, I block in the distant walls. I finish this stage by adding a little more texture in the foliage at right by stippling, softening in places with clear water.

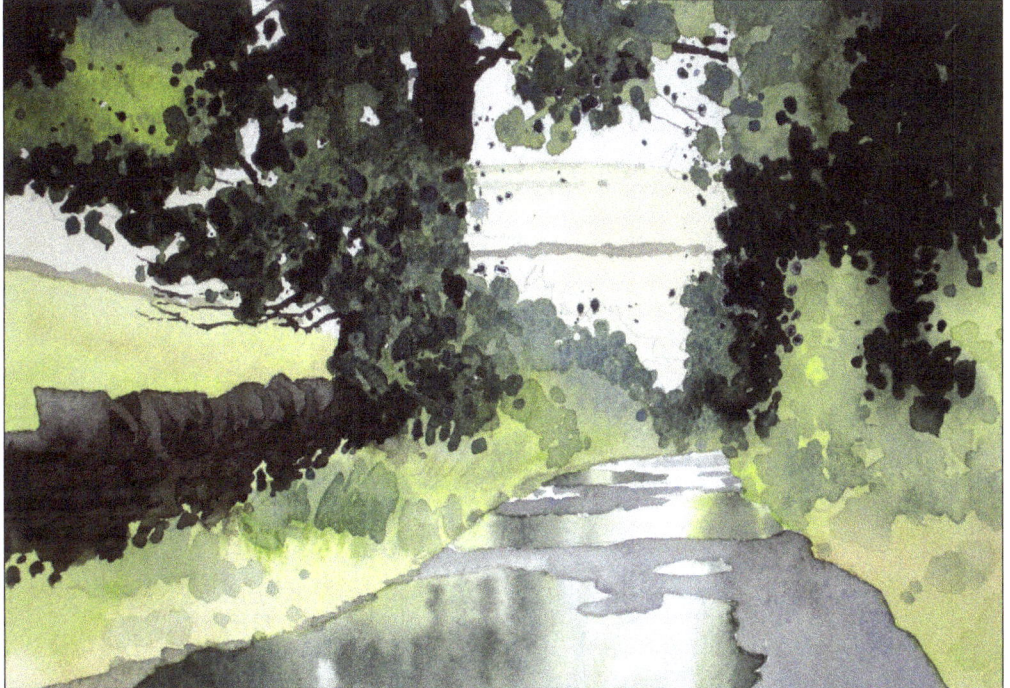

STAGE 4

6 minutes Using a small round brush and Payne's gray, I quickly add darker details to the wall. Then I address the puddles in the road, first wetting the shapes in preparation for the wet-into-wet technique. Then, using the same colors that I used to create the trees, I brush in the reflections with downward strokes. I dry the area with the hair dryer and paint the dry areas of the road with a mix of French ultramarine, raw sienna, and Payne's gray. I am careful to achieve the correct value, as the road needs to stand out against both the dark and light areas of the puddles.

- *When painting trees, use a loose, spattered approach to achieve the natural look of foliage.*
- *For simple foliage, try using a pure green (straight from the tube) as a base, adding yellows and blues to vary its hue.*

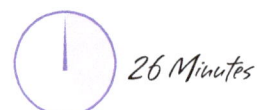 *26 Minutes*

WORKING IN MONOCHROME

It's inexpensive, there's no color mixing involved, and the results can be very dynamic. It sounds like a watercolorist's dream, yet many artists never consider creating a painting in *monochrome* (one color). Why? Probably because the painting would be difficult to sell—or perhaps the thought of an entire painting done in dull gray simply isn't appealing. But the advantages far outweigh the disadvantages: Doing a monochromatic painting can help you learn to see the differences in value and translate those varying values into layers of watercolor. By working with only one color, you don't have to worry about the complexities of color mixing and can concentrate instead on creating accurate patterns of lights, midtones, and darks. Value may not sound very interesting, but it definitely is in the world of painting. I find the process of placing lights against darks immensely exciting!

PALETTE
Payne's gray

STAGE 1

4 minutes I begin by sketching the scene on my watercolor paper and identifying the areas of white. In this case, the whites are the window frames of the building on the left and a small reflection on the road. These areas need to remain pure white. To make them stand out, I apply a mid-to-light value wash of Payne's gray over the buildings, foliage, and large tree trunk. While this initial wash is still wet, I brush in some slightly darker values, taking care not to go too dark too soon.

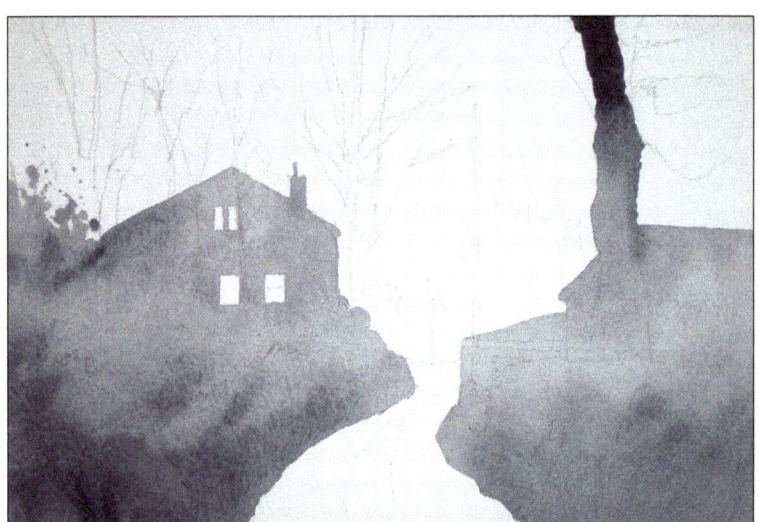

STAGE 2

7 minutes Next I bring up some select areas to a mid-value gray. To do this, I create a value on my palette that is roughly the same as that on the paper. When applied over the initial layer, the resulting tone is a bit darker. I work on the buildings, using the darker value to separate them from the foreground as well as create areas of stone detail. Then I suggest the rough banks with a few brushmarks; I also add some details to the roof. As the areas dry, I mix a mid-to-dark tone on my palette and block in the distant trees, creating some minor contrast.

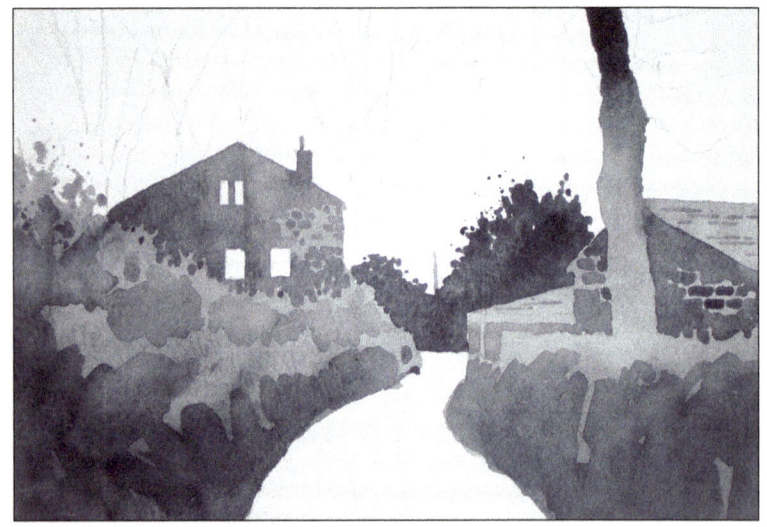

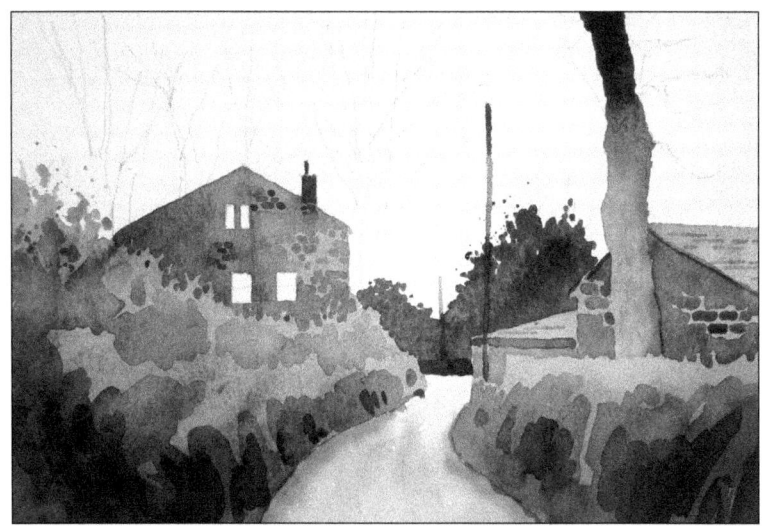

STAGE 3

5 minutes When the painting is dry, I continue adding varying values, working my way toward the darkest darks. I place further definition in the roadside banks and on the facing building. With each stage, I work darker washes over the previous washes, honing in on the deepest values and covering less and less of the paper's surface.

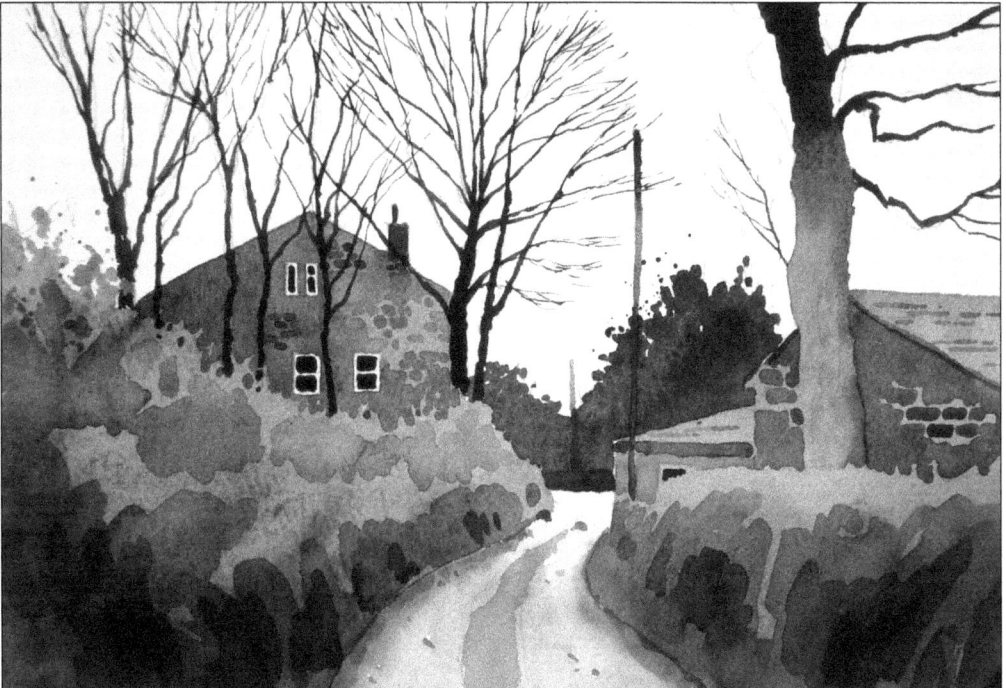

STAGE 4

10 minutes I work on the darkest sections of the painting using strong, almost pure Payne's gray. I reserve this deepest value for the windows and the silhouetted trees, which I paint with a very small round brush. I finish the trees with a rigger brush. Notice how these final, strong values unite all the other grays in the painting. The extreme lights and darks provide reference points for the midtones, establishing form and depth.

- *Try to complete your monochrome painting with only five values (light, mid-to-light, mid, mid-to-dark, and dark). With the white of the paper as the lightest light, there are only four stages altogether.*
- *Use a color that is capable of creating a full range of values, such as burnt umber, Prussian blue, or Payne's gray. Yellows are too light.*

 30 Minutes

MAKING PAINTINGS OUT OF NOTHING

Searching for scenes to paint sometimes can be a frustrating process, especially if you are new to painting or you are simply not sure what constitutes a good landscape. I often find very little in the way of interesting landscape features to paint while walking through the countryside, but years of experience have sharpened my visual eye; now I am able to find less obvious scenes. It has become a wonderfully creative challenge over the years to turn a faceless terrain into an exciting visual image. In this case, I have used atmosphere and strong light to override the lack of variety and content in the composition.

PALETTE
burnt sienna, French ultramarine, Hooker's green, lemon yellow, Payne's gray, Prussian blue, raw sienna, and sap green

EXTRAS
masking fluid, an old brush, and a hair dryer

STAGE 1

8 minutes I draw the scene on watercolor paper, ignoring any intricate details such as the value changes in the walls. With masking fluid and an old, fine brush, I mask the telephone poles and place some fence posts along the tops of the walls. After drying the mask with a hair dryer, I prepare the sky for a wet-into-wet wash. With Payne's gray and a little Prussian blue, I form the shapes within the sky. While the area is still evenly wet, I mix a strong wash of Prussian blue, Hooker's green, and Payne's gray and paint the distant hills below the sky on the left, creating a fuzzy edge and suggesting fog.

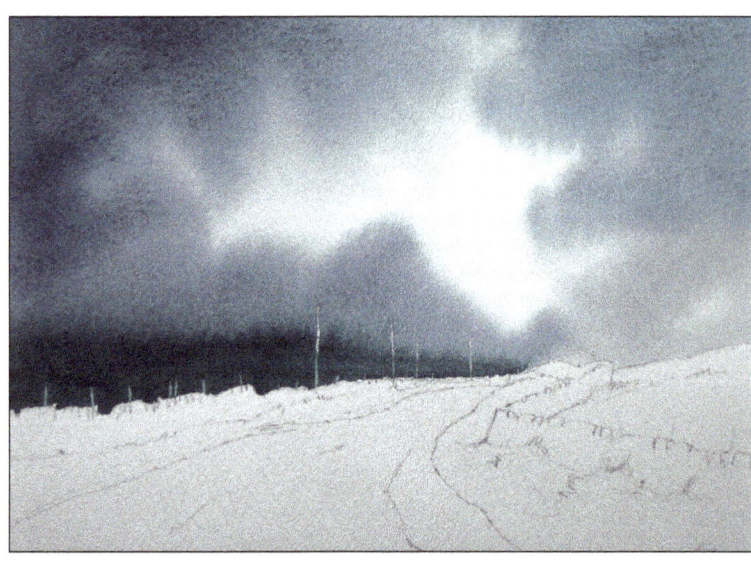

STAGE 2

5 minutes Now I paint the land while establishing the light areas at the same time. I use pure raw sienna, sap green, and lemon yellow in the lightest areas and allow them to mix on the paper. In the shadowed areas, I use the same colors plus a bit of Payne's gray, again allowing the colors to blend on the paper.

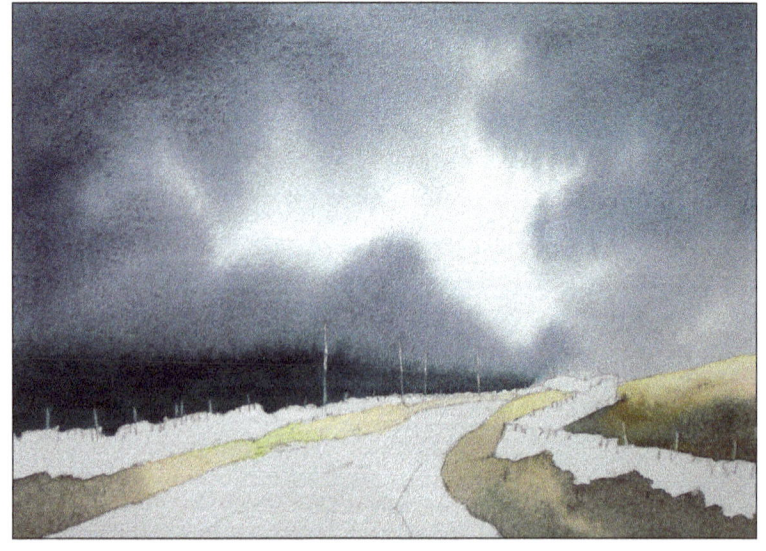

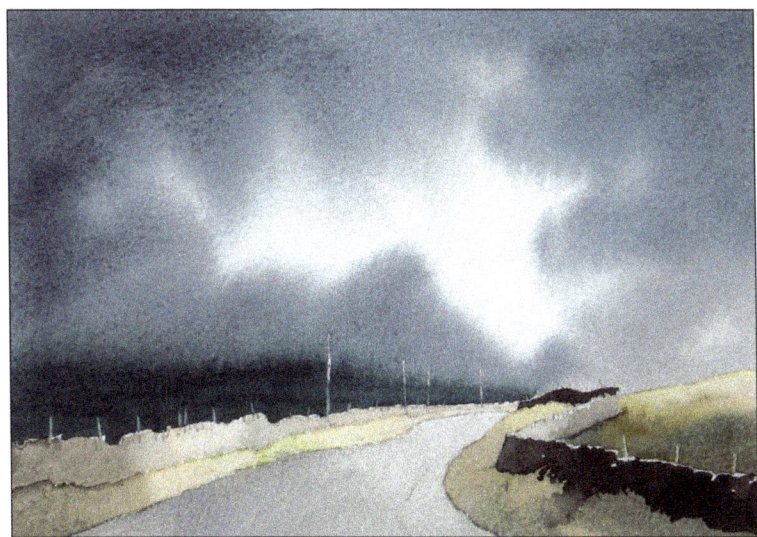

STAGE 3

6 minutes I use the same technique on the walls, applying raw sienna mixed with burnt sienna in the light areas and burnt sienna mixed with Payne's gray in the shadowed areas. The overall value of the walls in shadow is darker than everything else, so I use a strong mix with confidence. The contrast here also exaggerates the light effect. I use a mix of French ultramarine and raw sienna on the road, thinning it down as I move into the distance.

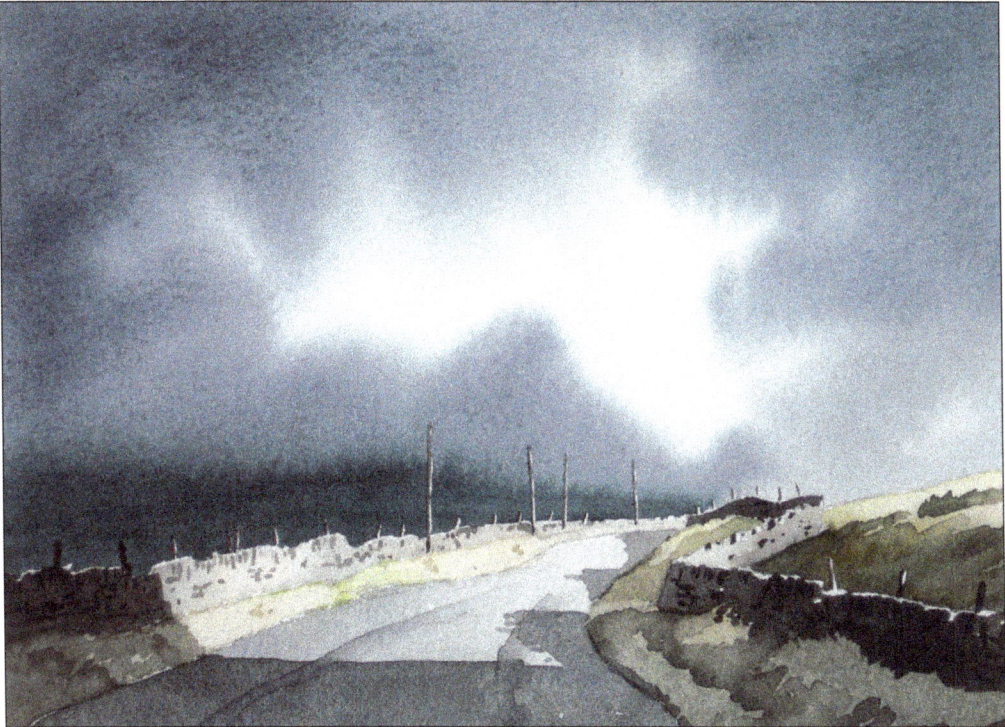

STAGE 4

11 minutes I add detail to the grass and walls using the same approach to color mixing. For example, I use pure colors for the light areas; then I mix each color with Payne's gray for their corresponding areas of shadow. Next I peel off the masking fluid and paint the shadowed sides of the poles with burnt sienna and Payne's gray. For the cast shadows on the road, I use French ultramarine and raw sienna plus a little Payne's gray.

- *Strong areas of shadow offer a great deal of contrast, allowing you to achieve an intense effect of light.*
- *When creating soft shapes wet into wet, use heavy (less diluted) paint with your paper lying flat.*

 25 Minutes

WINTER MOUNTAINS

As the kind of person who can't help poking his nose into things, I always have had a fondness for discovery. Paths have to be explored right to their ends, and rivers have to be waded into. Similarly, mountains have to be climbed to see what's on top. I don't know why I do it—it's incredibly hard work slogging my way upward for several thousand feet only to come back down again in a few hours. And more often than not, I end up with little more than a set of gray photographs and a few dull sketches; but occasionally nature allows me a sneak peek of the beauty that can be found among the hills.

PALETTE
burnt sienna, cobalt blue,
French ultramarine, light red,
and Naples yellow

STAGE 1

2 minutes After drawing the mountain shapes and a few indications of rocks, I begin with a pale wash of Naples yellow just above the mountain peak. Before it dries, I apply a light wash of cobalt blue in the sky, starting at the edges and letting the blue softly blend into the yellow. I allow the sky to dry before continuing.

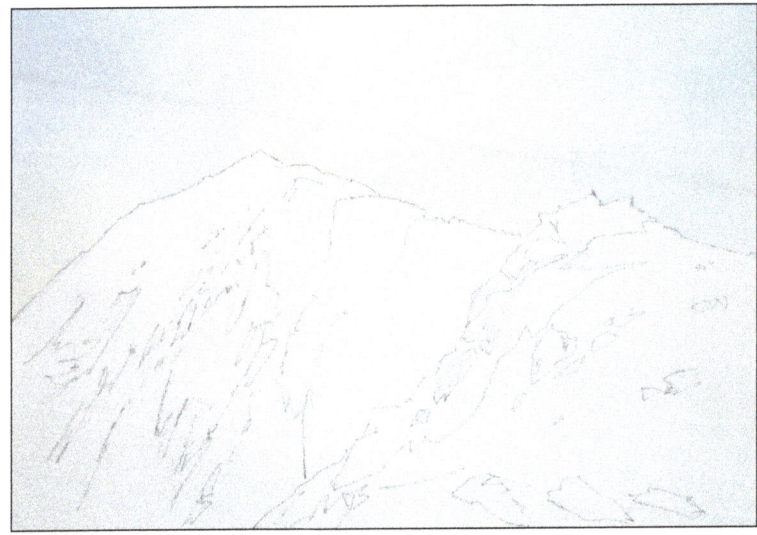

STAGE 2

7 minutes I paint the strong shadows on the mountainside with loose mixtures of French ultramarine and light red. I leave one or two spots of white paper on the mountain to indicate the sunlight. Next I bring the same mixture into the sunnier foreground section, taking care to capture the subtle shadow shapes and values.

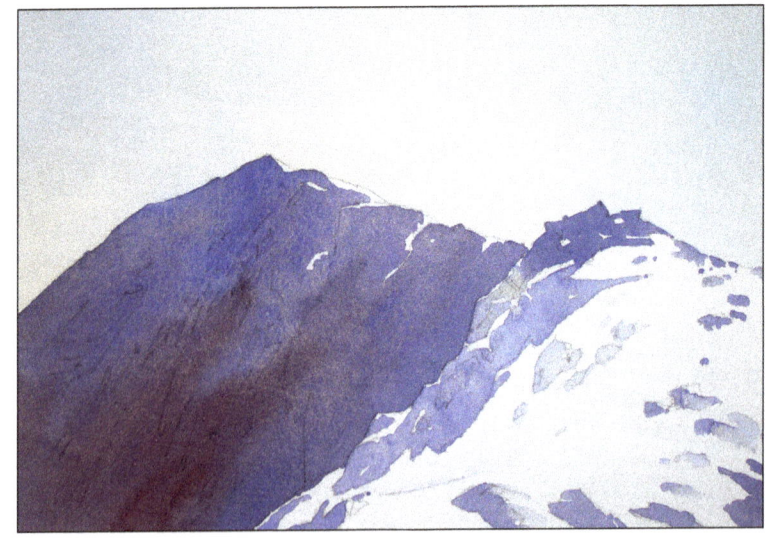

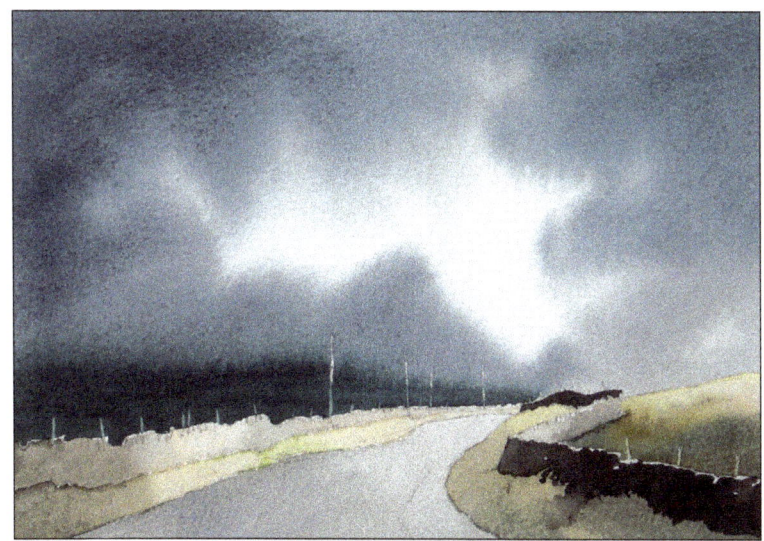

STAGE 3

6 minutes I use the same technique on the walls, applying raw sienna mixed with burnt sienna in the light areas and burnt sienna mixed with Payne's gray in the shadowed areas. The overall value of the walls in shadow is darker than everything else, so I use a strong mix with confidence. The contrast here also exaggerates the light effect. I use a mix of French ultramarine and raw sienna on the road, thinning it down as I move into the distance.

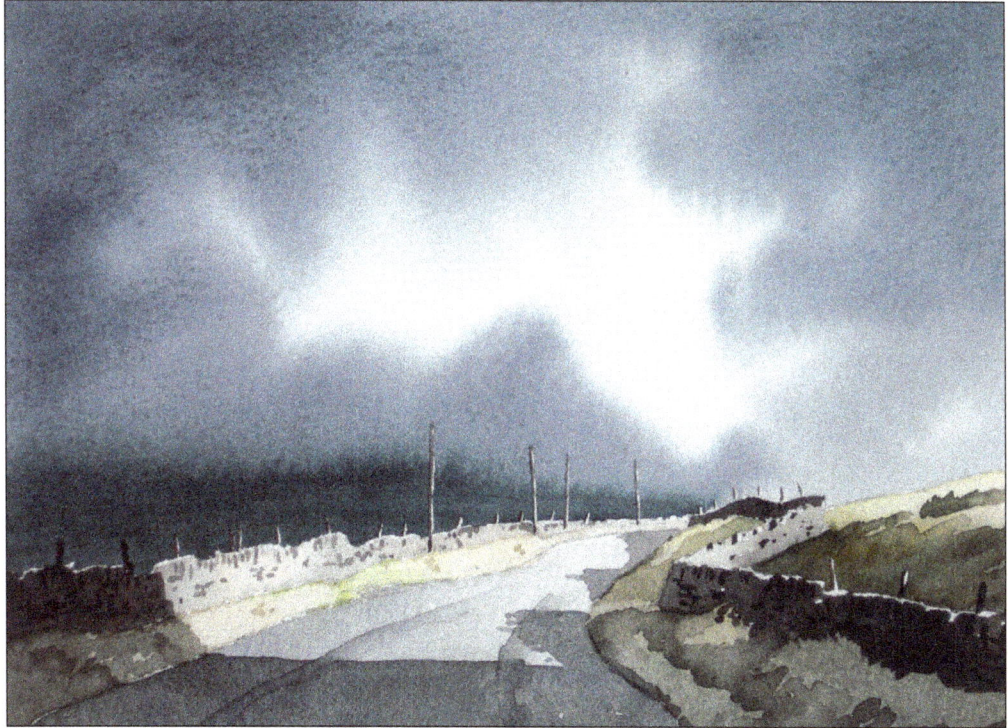

STAGE 4

11 minutes I add detail to the grass and walls using the same approach to color mixing. For example, I use pure colors for the light areas; then I mix each color with Payne's gray for their corresponding areas of shadow. Next I peel off the masking fluid and paint the shadowed sides of the poles with burnt sienna and Payne's gray. For the cast shadows on the road, I use French ultramarine and raw sienna plus a little Payne's gray.

- Strong areas of shadow offer a great deal of contrast, allowing you to achieve an intense effect of light.
- When creating soft shapes wet into wet, use heavy (less diluted) paint with your paper lying flat.

 25 Minutes

WINTER MOUNTAINS

As the kind of person who can't help poking his nose into things, I always have had a fondness for discovery. Paths have to be explored right to their ends, and rivers have to be waded into. Similarly, mountains have to be climbed to see what's on top. I don't know why I do it—it's incredibly hard work slogging my way upward for several thousand feet only to come back down again in a few hours. And more often than not, I end up with little more than a set of gray photographs and a few dull sketches; but occasionally nature allows me a sneak peek of the beauty that can be found among the hills.

PALETTE
burnt sienna, cobalt blue, French ultramarine, light red, and Naples yellow

STAGE 1

2 minutes After drawing the mountain shapes and a few indications of rocks, I begin with a pale wash of Naples yellow just above the mountain peak. Before it dries, I apply a light wash of cobalt blue in the sky, starting at the edges and letting the blue softly blend into the yellow. I allow the sky to dry before continuing.

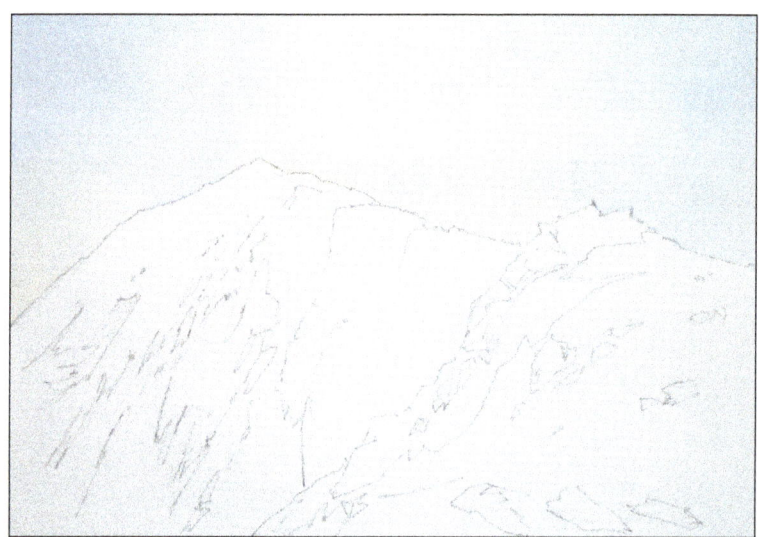

STAGE 2

7 minutes I paint the strong shadows on the mountainside with loose mixtures of French ultramarine and light red. I leave one or two spots of white paper on the mountain to indicate the sunlight. Next I bring the same mixture into the sunnier foreground section, taking care to capture the subtle shadow shapes and values.

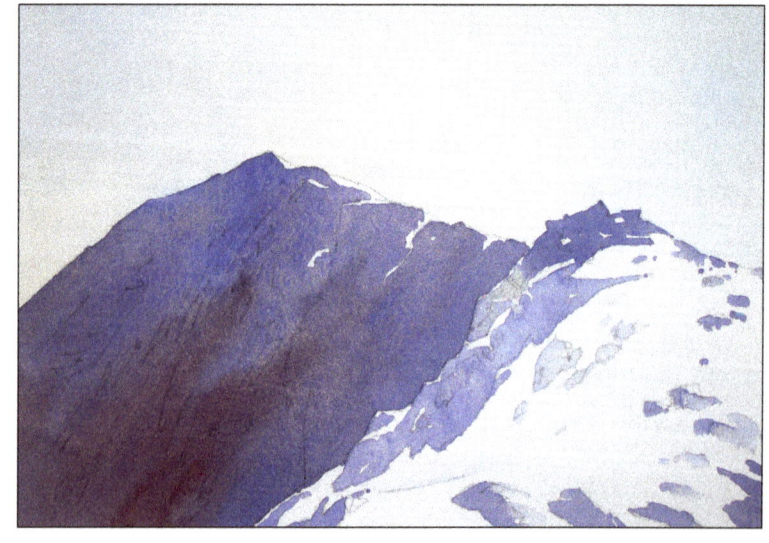

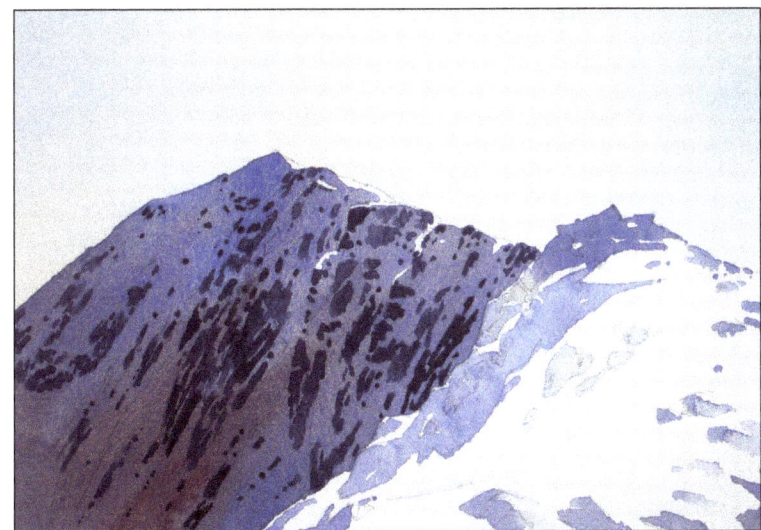

STAGE 3

10 minutes With a stronger mix of French ultramarine and light red, I apply the dark shapes of the distant rocks using a small round brush. Although this may look complex, it is simply a series of marks that I paint quickly and spontaneously.

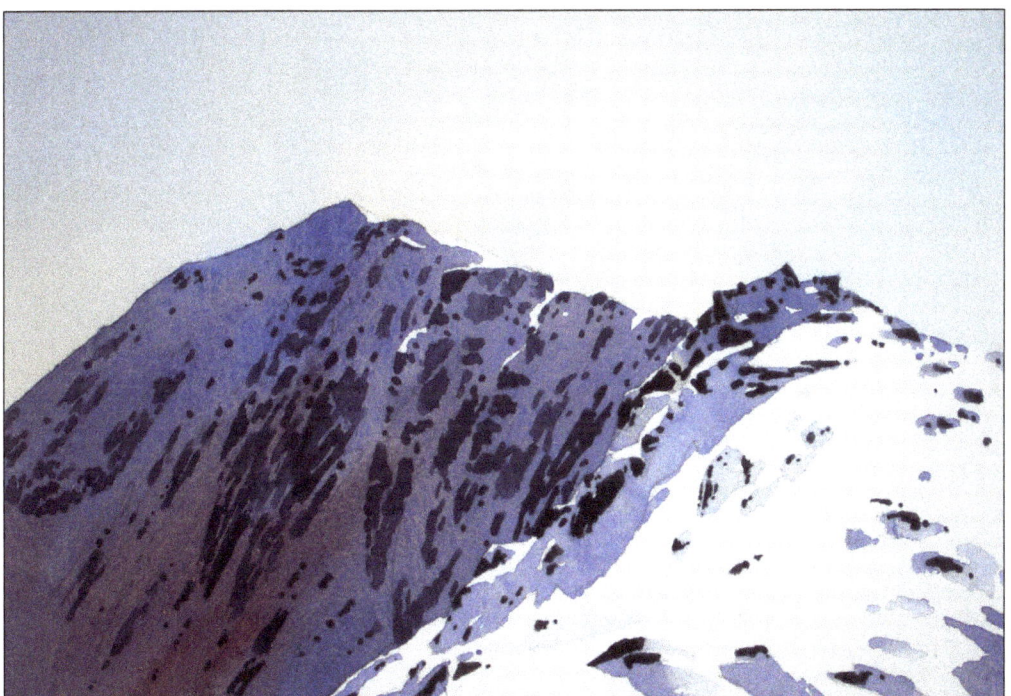

STAGE 4

6 minutes I use a very strong mix of French ultramarine and burnt sienna for the foreground rocks. This stronger, grayer color helps bring the foreground forward and push the background into the distance. I use a small round brush and again apply a series of quick marks rather than carefully painted shapes.

- *When painting mountains, brush on the main color washes in the direction of the slopes to help describe the shape of the land.*
- *Areas of white usually reflect ultraviolet rays in their shadows, so use blues or violets to depict the shadows.*

 28 Minutes

A MISTY DAY

Capturing the subtle effects of mist in watercolor may seem difficult to achieve, but in reality no other painting medium lends itself to the subject quite as well. Just add plenty of water and away you go! A few friends and I endured hours of torrential rain while we were at this scene, and this painting depicts the end of our day's walk when the rain had finally stopped. The fine mist among the trees was just crying out to be painted in watercolor. Mist on the landscape is so evocative that even the Masters used it in their paintings to create a sense of romance. While depicting subjects shrouded in mist, make sure you use stronger tones in the foreground to provide depth—otherwise your painting may look washed out, so to speak.

PALETTE
alizarin crimson,
burnt sienna,
French ultramarine,
Hooker's green, and
raw sienna

STAGE 1

4 minutes I use a 4B pencil to lightly draw the position of the trees, the figures, and the line of the path. I don't intend to follow these lines precisely, though, as I wish to create a loose, spontaneous feel by using my brush as a "drawing" tool. Next I wash in heavily diluted mixes of French ultramarine and burnt sienna over the sky areas. Then I apply stronger mixes of the same colors wet into wet to suggest the soft, blurry trees in the distance. For the slightly closer trees on the right, I add a touch of Hooker's green to bring in some color.

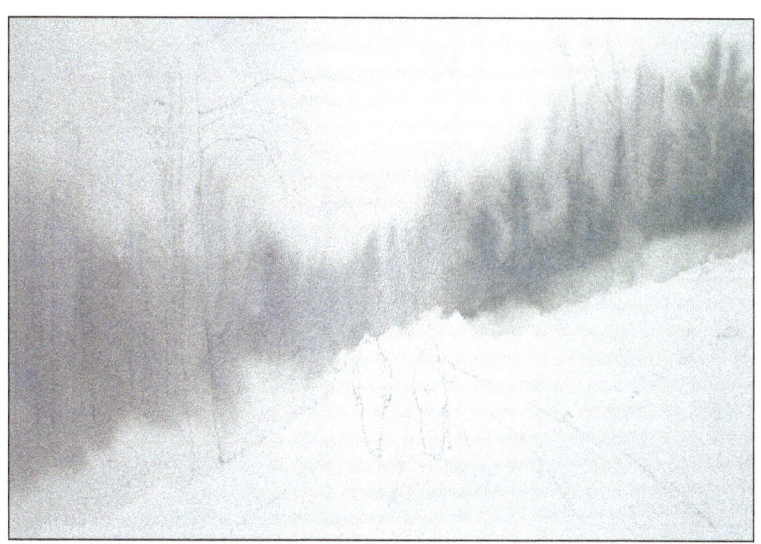

STAGE 2

5 minutes Next I paint the bare trees on the right with the tip of a very small round brush and a wash of French ultramarine with a touch of burnt sienna. I soften the trees at their bottoms with clean water and then brush a variegated wash of raw sienna, burnt sienna, and French ultramarine over the ground.

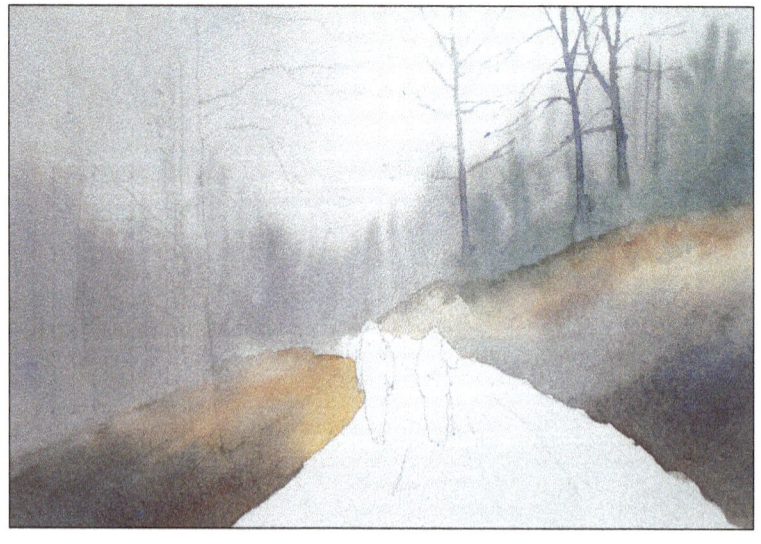

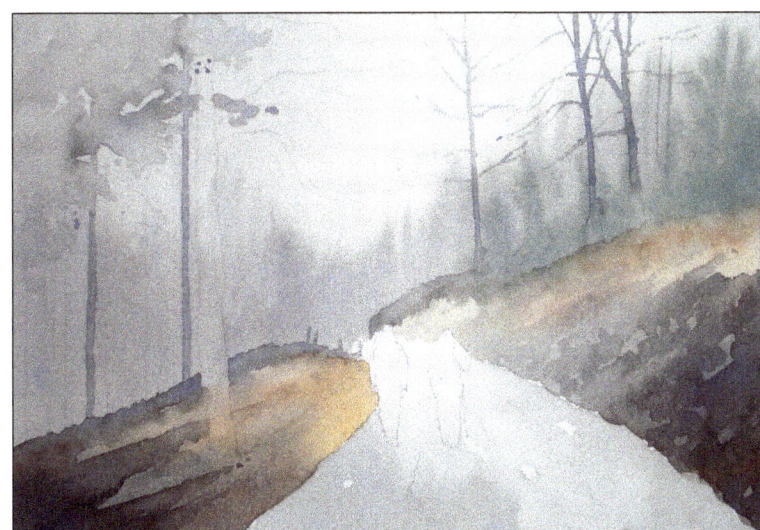

STAGE 3

8 minutes I add a couple of tall, thin trees on the left with a medium-value mix of French ultramarine and burnt sienna; then I add a few details to the ground using the same color mix in varying strengths. Still using the same mix, I paint the shape of the wall. Then I add more water to the mix and wash in the very pale tones of the wet path. I wait for all the washes to dry before continuing.

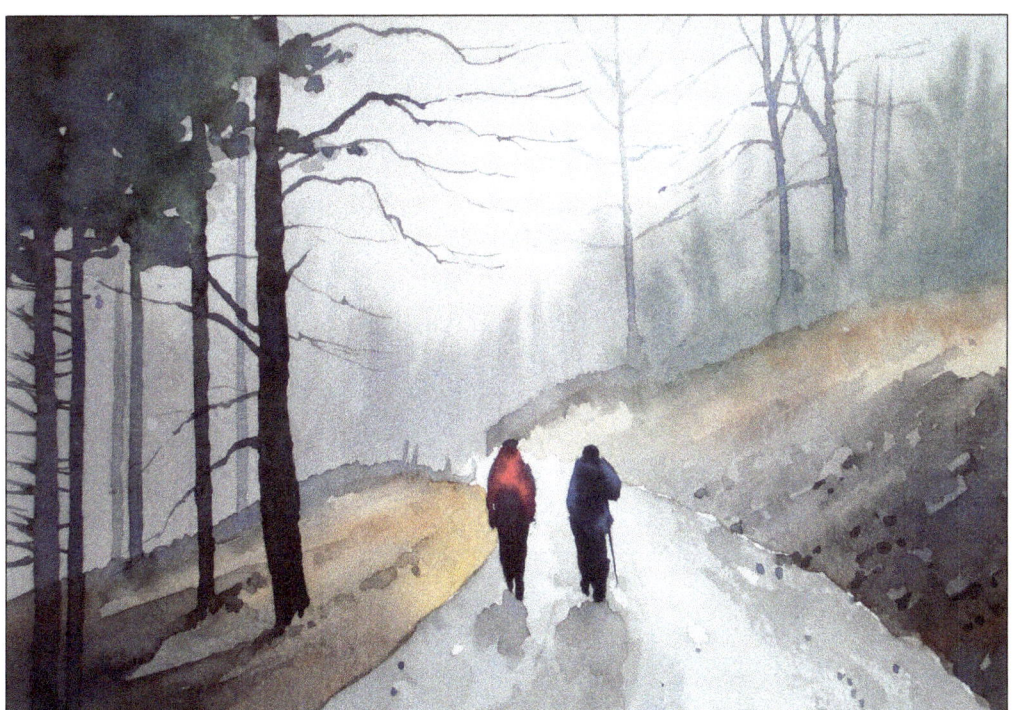

STAGE 4

11 minutes Now I paint the nearest trees with much stronger mixes of French ultramarine and burnt sienna, introducing some Hooker's green into the foliage. I detail some of the branches with a rigger brush and emphasize a few rock details on the right-hand side. To add shadows and detail to the path, I use a medium brush and apply washes of French ultramarine and burnt sienna. I paint the figures last with strong washes of French ultramarine and burnt sienna. I finish with a splash of alizarin crimson on the figure on the left to provide the focus of the painting.

 35 Minutes

WATERFALLS

I have a painting of a waterfall that I completed about eight years ago, and I take prints of it with me to my demonstrations and workshops. I quite often am asked, "Did you use masking fluid for the falling water?" The answer is short and simple: No. Falling water is made up of hard and soft edges, and masking fluid is too harsh for this effect. For the hard edges within the waterfall, I leave the paint as is; for the soft edges, I use a damp brush to pull out wet paint. I find that it's imperative to use a combination of these techniques to give the water a realistic look. For the splashy feel of the water, I generally use a stippling technique with a round brush. This painting may look complex, but it's simply a series of stippled brushstrokes.

PALETTE
burnt sienna, burnt umber, cobalt blue, light red, Payne's gray, raw sienna, sap green, and violet

STAGE 1

8 minutes I sketch the scene on a piece of extra-rough watercolor paper and begin laying in the midtones. I use cobalt blue mixed with light red for the water, stippling the wash as I approach the white water beneath the falls. Then I work on the lighter colors of the falls, mixing raw sienna and burnt umber to depict the peat-colored water. I paint the large rock in the middle of the scene with cobalt blue and burnt sienna, adding some sap green for the mossy area. I use Payne's gray mixed with burnt sienna for the rock's shadows.

STAGE 2

11 minutes When the initial washes are dry, I work on the negative shapes between the dark rocks that are seen through the splashes of the falls. For the darkest rocks, I use a very small round brush with a wash of burnt sienna and Payne's gray, varying the amounts of each on the paper and occasionally softening my strokes with water as I paint. Using a medium round brush, I apply a large wash of the same colors for the dark water (bottom right), adding violet to the wash as I approach the edge of the painting. I "sketch" with the brush rather than paint definite lines; this helps simplify the subject and breathe life into it.

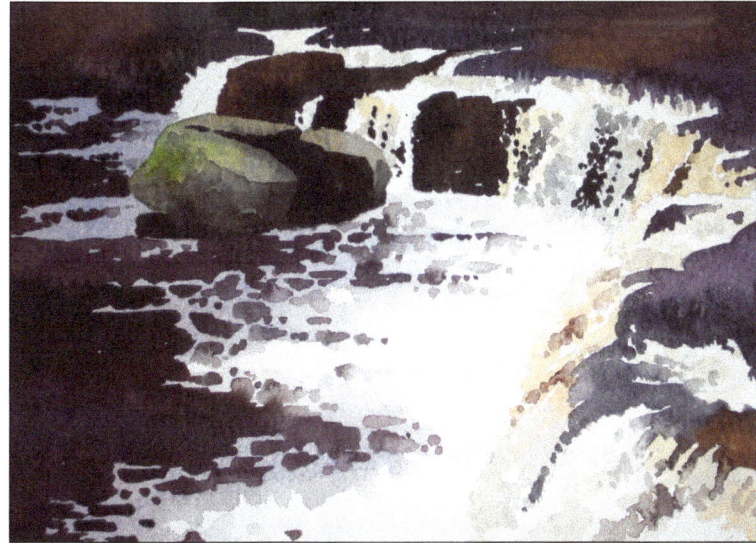

STAGE 3

7 minutes Next I work on the dark water on the left. I brush in Payne's gray, burnt sienna, and violet, allowing them to mix on the paper. I work this wash toward the white water, where I stipple the edges and soften them in areas.

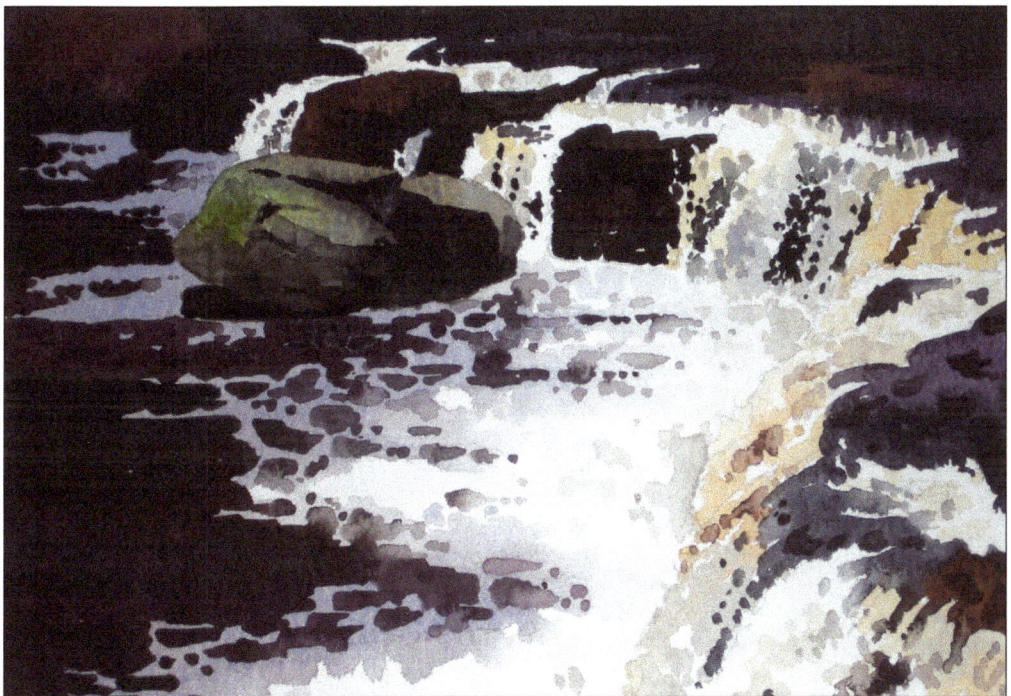

STAGE 4

9 minutes Finally, I add some detail to the rocks with a strong mix of burnt sienna and Payne's gray. I also suggest movement and ripples on the surface of the water with a few brushstrokes of violet and burnt sienna.

- Using a blunt round brush (one that doesn't taper to a sharp point) for stippling water produces softer, rounder shapes.
- Leave plenty of white paper showing to represent the falling water and to contrast with the strong tones of the rocks.
- Don't try to copy the effects of water too closely; a looser approach to painting will instill life and movement.

 23 Minutes

PAINTING SNOW SCENES

Snow makes such a fantastic contribution to a landscape—it's a pity that it rarely seems to last. Over the years I have become somewhat of a snow chaser, watching the weather patterns and getting my camera and sketchbook ready as soon as the first few flakes begin falling. My behavior may seem a little extreme, but snow scenes are a refreshing change from all the greens of summer! Landscapes that might be dismissed as dull subjects at other times of the year are transformed into vibrant patterns of contrast, color, and shadow. With the majority of snow scenes either being white or having a blue cast, the artist can bypass the complexities of juggling several colors, and the painting process can be made much simpler. Plus, the low light of wintertime provides a dramatic bonus.

PALETTE
French ultramarine, light red, Payne's gray, and raw sienna

EXTRAS
masking fluid and an old brush

STAGE 1

4 minutes I draw the scene using a 4B pencil. Then I mask out some fence posts and a patch of ground with liquid frisket. My intention is to create a splash of light within the large shadowed foreground area. While this dries, I apply a loose mix of French ultramarine and a touch of Payne's gray into the sky, leaving a hard outline along the horizon. When dry, I use the same colors to block in the large shadow area across the foreground, working around the highlight on the left side of the path. This wash appears to be quite strong, but it needs to contrast with the lighter parts of the painting.

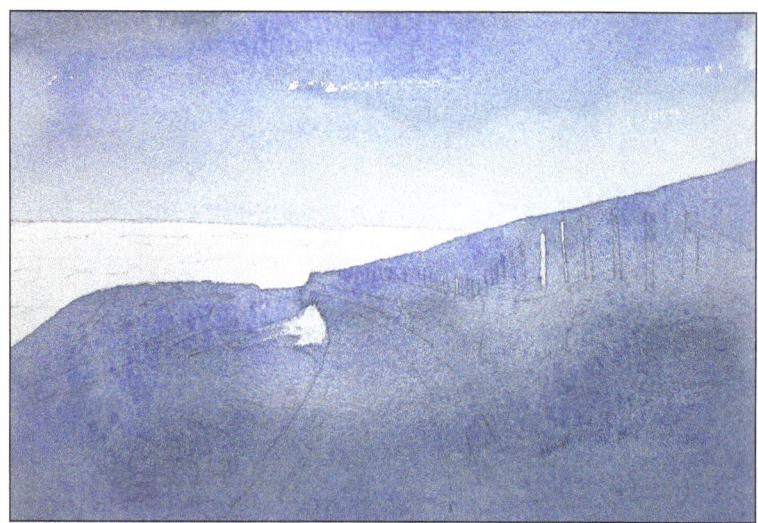

STAGE 2

12 minutes I suggest some features in the distant, sunlit ground with a pale mix of light red and French ultramarine. For the dark ground areas, I use a very small round brush and strong mixes of French ultramarine, light red, raw sienna, and Payne's gray. I paint these areas loosely, stippling to suggest small rocks and the stones of the wall. On the right side of the path, I pick up the warmer colors of the grasses by introducing raw sienna to the color mixes.

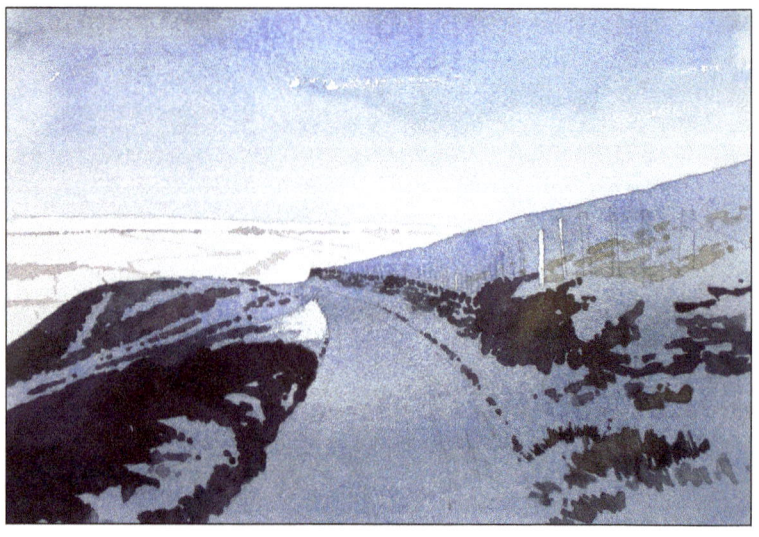

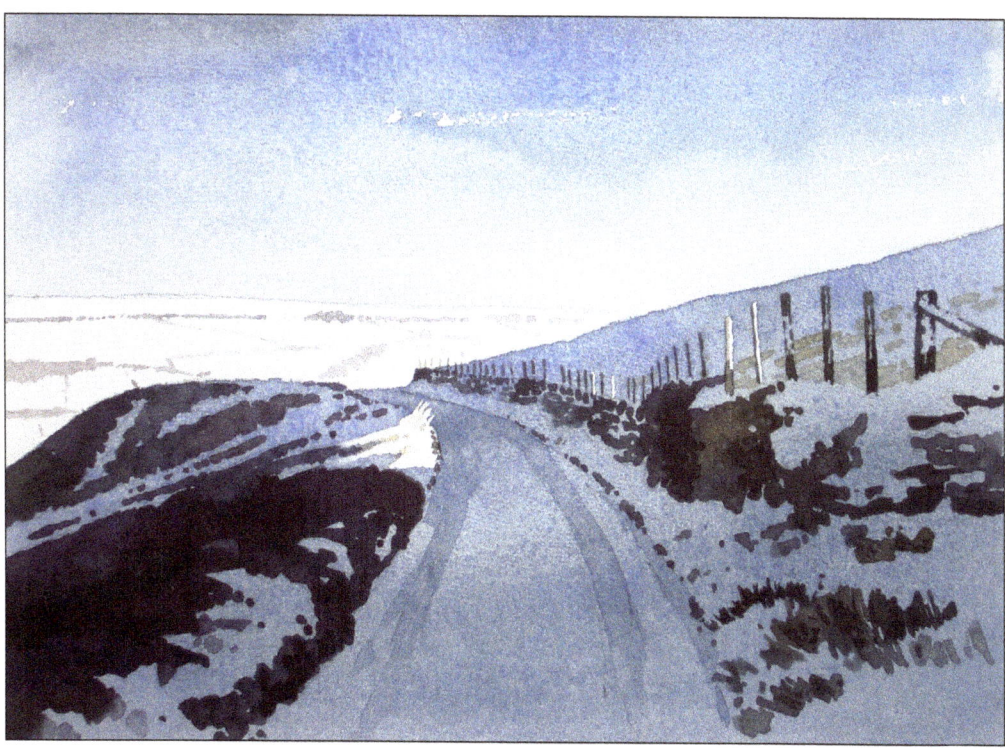

STAGE 3

7 minutes I remove the masking fluid and then paint the fence posts with mixes of light red and Payne's gray. I use raw sienna to reflect the warmth of the light where the sun hits the posts. With a dark mixture of light red and Payne's gray, I reinforce some of the darker areas in the foreground. I finish the painting by suggesting some tire tracks on the path with a mix of French ultramarine and Payne's gray, which I make only slightly darker than the initial wash.

Details

Light Versus Shadow Shadows in a snow scene reflect ultra-violet light, making them appear blue in color. Compare this to the bright white of the sunlit hillside in the distance.

Foreground Rocks The patterns left by fallen snow over the ground are generally abstract. Simply communicate the flow of the shapes, brushing them freely and loosely.

27 Minutes

USING A LIMITED PALETTE

Using a limited palette can be very beneficial for learning about tones and the use of color in creating distance and atmosphere. If selected carefully, three colors can give you a large scope to work with. For example, let's use light red, burnt sienna, and cobalt blue—two earthy colors and a blue. With cobalt blue and light red, you can create shades of gray violet, which are ideal for distant and cool-colored features. With cobalt blue and burnt sienna, you can create warmer, stronger tones, which are ideal for foreground features. Using a very limited palette in this way is a great way of exaggerating atmosphere in a landscape.

PALETTE
burnt sienna,
cobalt blue, and
light red

EXTRAS
masking fluid, an old brush,
and a hair dryer

STAGE 1

10 minutes I start by drawing the scene and using masking fluid to protect the shape of the boat. As soon as this dries, I use a large round brush to apply a pale wash of light red in the middle of the sky. I paint around the shape of the sun and work my way toward the edges of the paper, where I add cobalt blue to the light red. Near the edges of the paper, I use stronger washes. Continuing down the paper, I reflect the colors into the wet, sandy bay, leaving a vertical "shimmer" of white paper in the center for the reflected light source. As soon as the wash dries, I paint the faint background of hills with pale light red.

STAGE 2

5 minutes I mix a midtone value of light red and cobalt blue and carefully paint the elongated horizontal pattern of the distant water. Using the same mix diluted with more water, I roughly describe the foreground pattern in the sand left by the tide. I soften some of the edges of the shapes with clean water as I paint.

STAGE 3

4 minutes I add a second application of the sand shapes using light red and cobalt blue. I don't simply cover the same areas again but, instead, vary the shapes and tones for a sense of depth. I create a very strong mix of cobalt blue and burnt sienna to paint the dark rocks at left and in the center of the composition. Then I dry the washes with a hair dryer and remove the masking fluid.

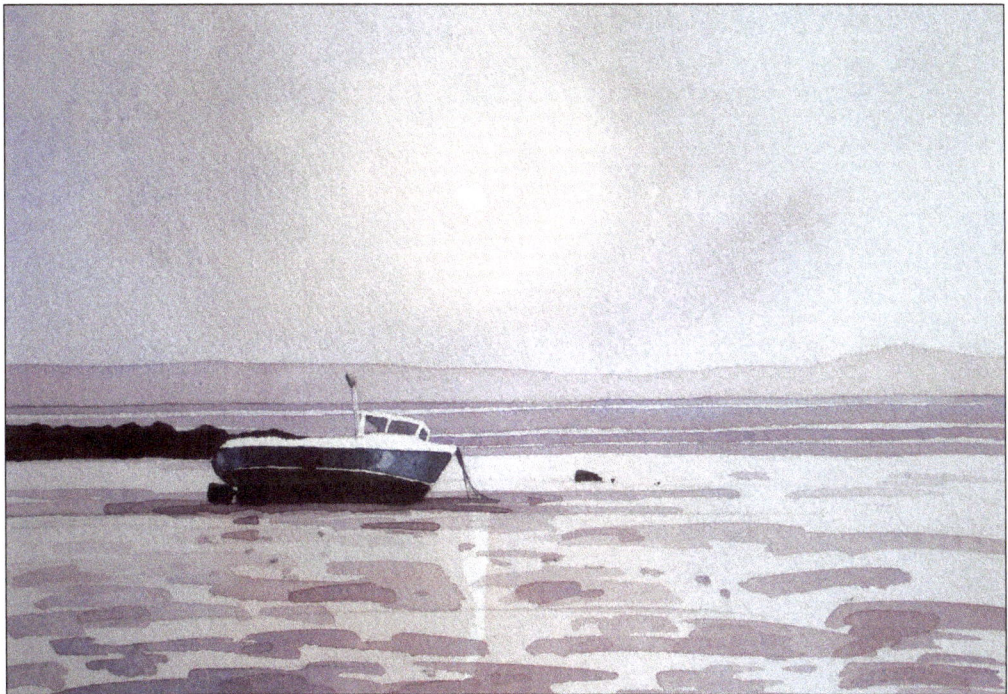

STAGE 4

8 minutes I use cobalt blue mixed with a little burnt sienna for the blue of the boat; then I use the same strong mix for the rocks underneath it. I dilute this color with water to create a lighter gray, which I use for the interior of the cabin. I dry the paint with a hair dryer, again; then, with a clean, damp brush, I carefully lift out some reflections on the boat. I use a little more cobalt blue and light red beneath the boat, and I finish by adding the mooring ropes with cobalt blue and burnt sienna.

- When using a limited palette, make sure at least two of the colors are capable of creating intense darks.
- Try to use no more than three colors, and think about how they will work together before you begin.

 30 Minutes

AROUND THE GARDEN

You don't have to travel a great distance to find an interesting landscape—try looking in your own yard or garden! For a fresh look at familiar surroundings, zoom in on corners and nooks to isolate potential subjects. For example, a collection of potted plants can make a very enjoyable study. Look for patches of shade under a tree to see if there are any interesting patterns of light to contrast with the shadows. I once took about 20 photographs of a young lettuce in the sunlight simply because its translucency had me transfixed. Choosing a subject near your own home also has its benefits in that you can return to the subject time and again, and you can guarantee that no one will be looking over your shoulder as you paint!

PALETTE
burnt sienna,
cobalt blue,
French ultramarine,
Hooker's green, lemon yellow,
Payne's gray, raw sienna,
and sap green

EXTRA
hair dryer

STAGE 1

7 minutes Working with a medium round brush and a variegated wash of sap green, lemon yellow, and raw sienna, I loosely wash in the lightest tones of the foreground grass, the plants in front of the shed, and the distant trees visible through the hedge. I dry the painting with a hair dryer and then immediately place the midtone wash for the hedge using Hooker's green, French ultramarine, and Payne's gray. I apply each color generously on the paper, allowing the colors to blend where they meet.

STAGE 2

7 minutes After the initial washes are dry, I use a medium round brush to work on the textural effect of the hedge, spattering and stippling with varied mixtures of Hooker's green, French ultramarine, and Payne's gray. I switch to a very small round brush to apply washes of raw sienna and burnt sienna for the pathway and the legs of the table.

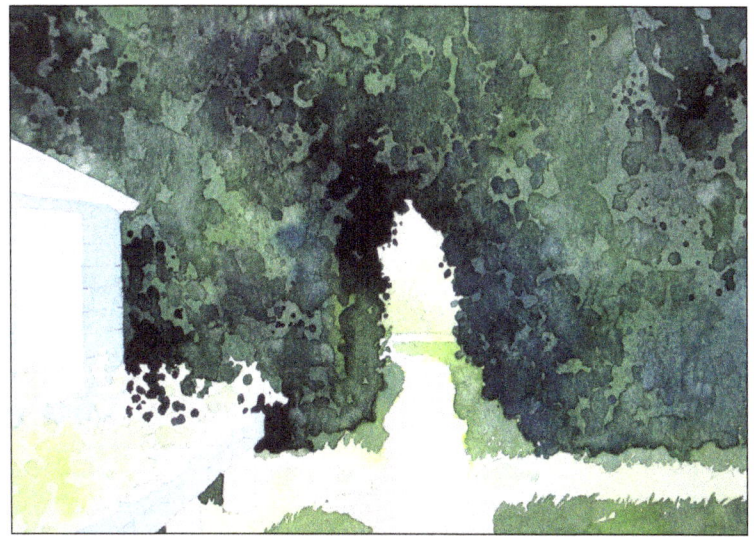

STAGE 3

7 minutes Next I work on the shed, painting the walls and the edge of the table with a diluted wash of cobalt blue. I add a very pale wash of Payne's gray for the roof. I paint the shadowed parts of the grass with a medium value of sap green mixed with French ultramarine. Then I water down this wash and stipple a few shapes into the plants in front of the shed.

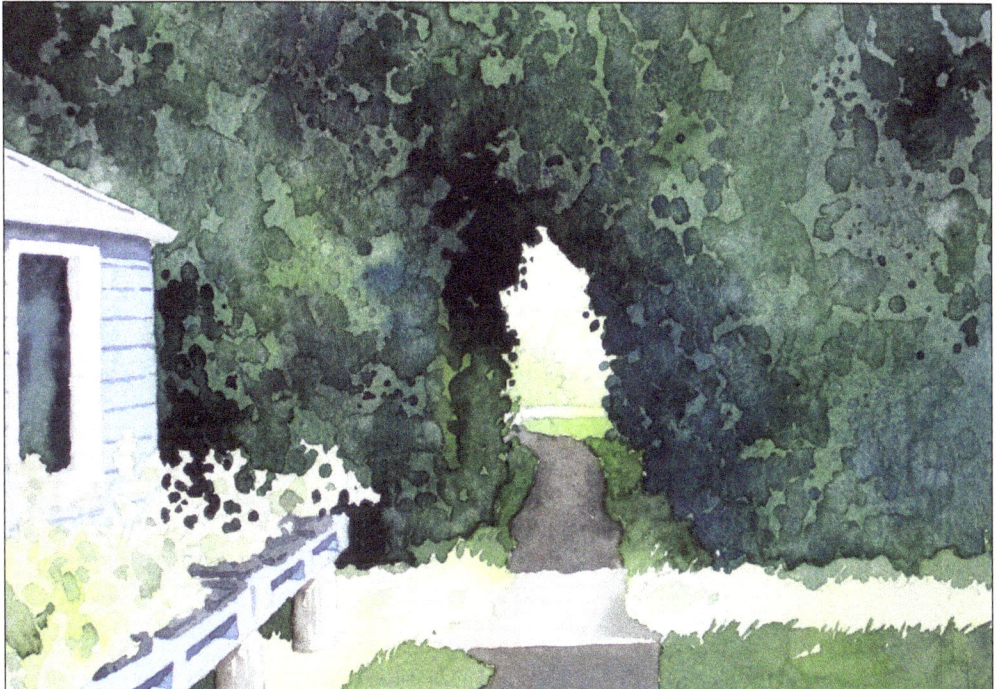

STAGE 4

9 minutes Now I work on the window, which reflects the surrounding colors. For this I brush in Hooker's green and cobalt blue; then I add Payne's gray wet into wet for the shadows around the edges. For the details and shadows on the shed wall and table, I use cobalt blue mixed with a bit of Payne's gray. While the paint is settling, I add shadows on the path using raw sienna mixed with Payne's gray. Then I return to the table and paint the seed trays with Payne's gray. Finally, I use raw sienna and Payne's gray to strengthen the shadow on the pathway underneath the hedge and stipple a little more color in the plants on the left.

- *Use varied colors brushed loosely together for initial washes; details can be worked on top of them when the washes are dry.*

 34 Minutes

CREATING PATTERNS

Not every painting has to be based around the traditional arrangement of two-thirds sky to one-third land, a focal point, a background, and a lead-in element. Quite often I like to bend the rules, especially where composition is concerned. Sometimes there isn't a background in my painting, so I use something like a cloud or a heavily toned area to add weight. Sometimes my paintings don't even contain a focal point, and I rely on patterns for the center of interest. Patterns can be constructed from patches of light, ripples of water, or clusters of tree branches. This painting revolves around the arrangement of the three tree trunks, which form patterns of tone and shape.

PALETTE
burnt sienna,
French ultramarine,
Hooker's green, lemon yellow,
Payne's gray, raw sienna,
sap green, and violet

EXTRA
hair dryer

STAGE 1

8 minutes I draw the tree shapes with a 4B pencil and then add a very pale wash of lemon yellow with just a touch of sap green and raw sienna over the areas that are in sunlight. I apply each color directly on the paper, blending them as I paint. After speeding up the drying time with a hair dryer, I create the strong pattern in the background using violet and Hooker's green. With a damp, blunt medium round brush, I stipple the background to create a few crisp areas of light.

STAGE 2

9 minutes After allowing the painting to dry completely, I apply the strong tones of the three tree trunks. Although you may think of trees as being brown, on closer inspection you are likely to discover various other colors, reflected light, and cool or warm shadows. For these trunks, I use a variegated wash of burnt sienna and violet. For the dark shadows, I add Payne's gray and French ultramarine. I keep the wash flowing by using plenty of paint and water.

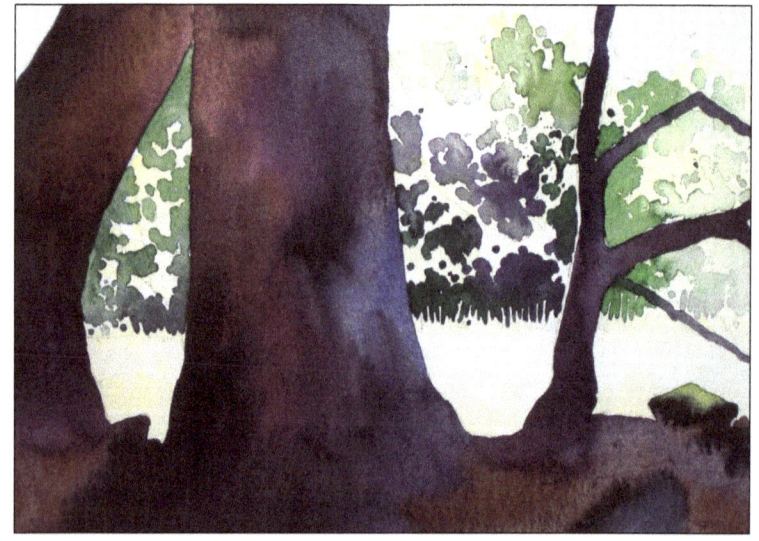

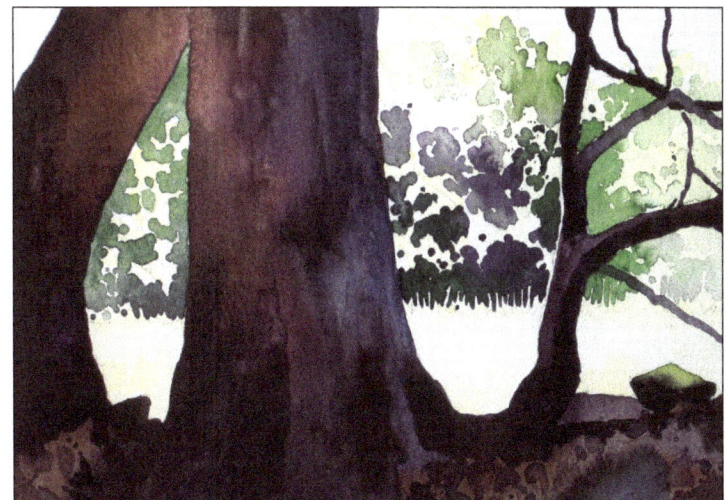

STAGE 3

8 minutes When the paint dries, I return to the tree trunks with stronger mixes of the same colors I used in stage 2, creating form and tone. I also stipple some of these dark washes into the leafy undergrowth.

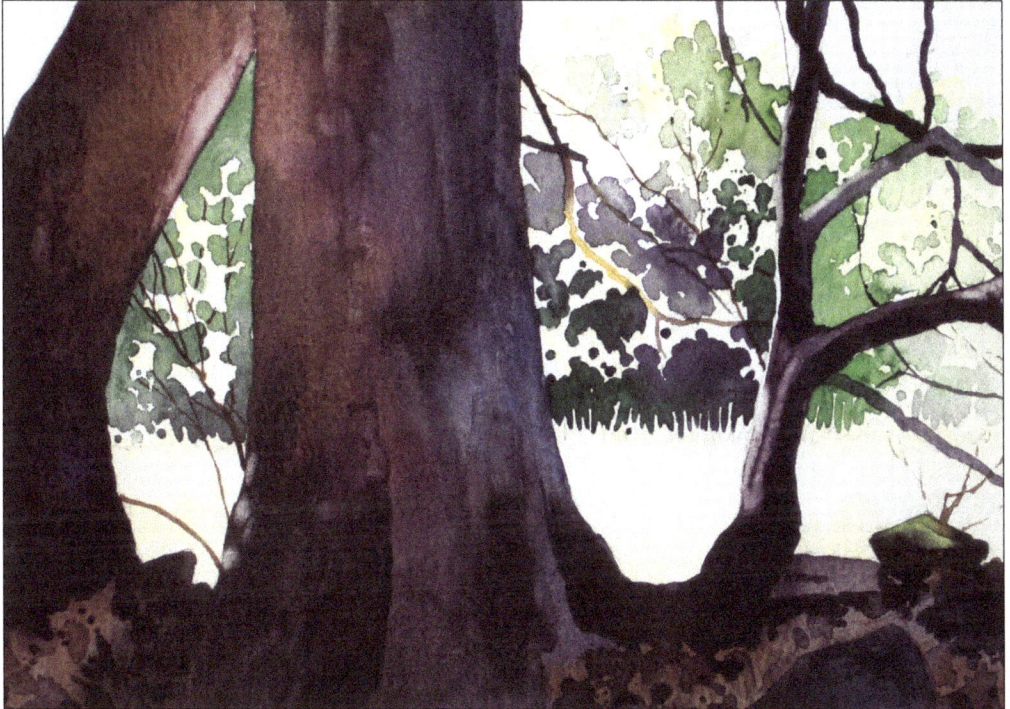

STAGE 4

9 minutes I use a damp brush to lift out some highlights in the lighter areas of the trees. Using a rigger brush and long strokes, I paint the twigs and finer branches with varying strengths of burnt sienna, raw sienna, and Payne's gray. Then I finish the piece by darkening the foreground rock with Payne's gray and burnt sienna.

- *Use a well-loaded round brush for stippling. A blunt brush is ideal, as this produces rounded shapes that are perfect for foliage.*
- *To create fine lines, use a rigger with the point as straight down as possible, resting your hand on the paper for support.*

 20 Minutes

RENDERING SUNSETS

For sheer color indulgence, there is nothing quite like a sunset. I often take to higher ground where I live to study them. Winter sunsets are my favorite, as the colors tend to be clearer than they are during summer. I found a fantastic vantage point a few years ago where the warmer colors of the direct sunset can be viewed from the comfort of a rock outcrop. By turning 180 degrees, I also can study the eastern violets, reds, and blues. This painting reflects the eastern colors of a sunset over a body of water.

PALETTE
alizarin crimson, burnt sienna, cobalt blue, French ultramarine, light red, and Naples yellow

STAGE 1

5 minutes I sketch the scene and begin preparing for a wet-into-wet wash by wetting the paper. I use a 1" flat brush to apply clean water to the paper, achieving an even wetness by keeping the water moving. When the sheen on the paper has disappeared, I add another layer of water and brush it around as before. Once the finished sheen has a satin appearance, I apply paint. I use some Naples yellow where the sky is lightest and follow up with varied washes of alizarin crimson and cobalt blue. I keep my strokes loose to achieve soft sky shapes. Then I create the general reflection in the water using the same colors.

STAGE 2

4 minutes As soon as the previous washes are dry, I mix cobalt blue with alizarin crimson and paint the distant hill at right. Then I mix French ultramarine with light red and paint the dark hill at left. This mix is stronger in value, bringing the hill on the left closer to the viewer than the other hills.

STAGE 3

4 minutes Using a medium round brush, I use cobalt blue and alizarin crimson to paint ripples in the water. I use a controlled side-to-side motion with the brush, making the ripples smaller as I move into the distance.

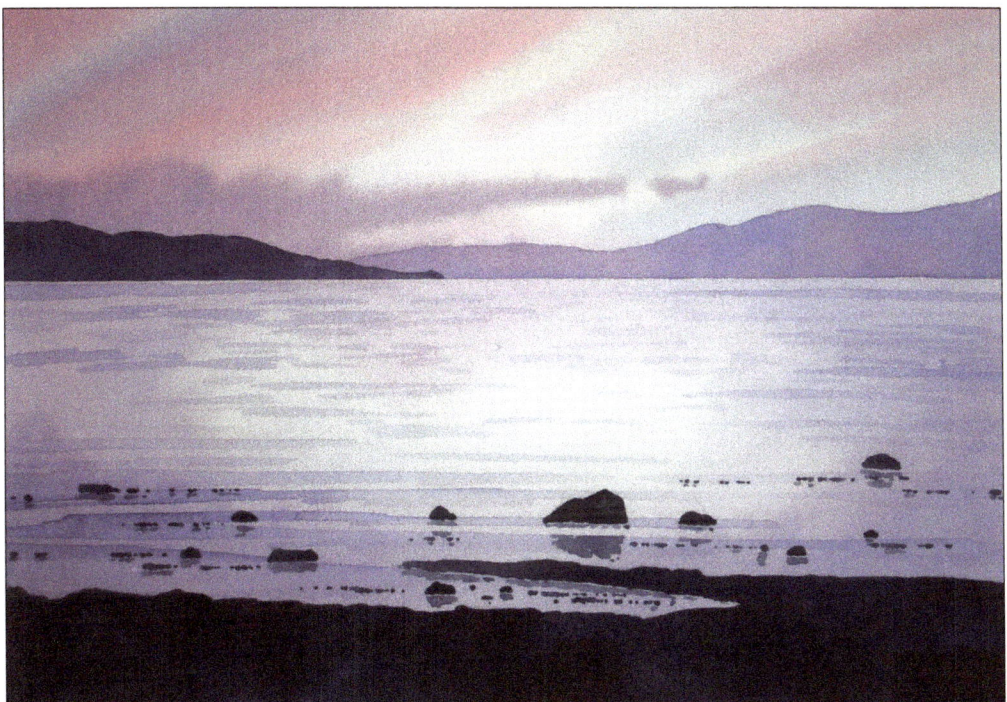

STAGE 4

7 minutes Now I paint the dark stretch of foreground using French ultramarine and burnt sienna. To make the wash more interesting, I mix the colors on the paper so that a little of each color shows. Then I add the rocks and seaweed bits using the same foreground colors. Finally, with a diluted mix of the same wash, I apply the soft reflections of the rocks.

- Use a thick paper for wet-into-wet washes; it will absorb plenty of water and stay moist longer than thinner papers.
- Aim to paint the foreground with intensely dark washes, as this contrast will create a stronger effect of light.

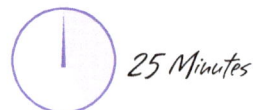 *25 Minutes*

FEBRUARY LIGHT

An artist's résumé makes fascinating reading material as it can tell you what makes the artist tick and what inspires him or her most. Many artists generally are driven by a particular subject—atmosphere in the landscape, figures, portraits, color, and so on. One subject that motivates hundreds of artists, myself included, is light. I recently became aware that I was heavily inspired by light when my painting suddenly took off on a tangent, leading me to tackle subjects that I never would have dreamed of painting just a few years before. I realized that my primary inspiration had become the effects of light, shadow, and contrast—and that the subject matter is secondary. I've found that February is the key time for light chasers, as the cold but clear atmosphere allows for strong, pure, low light for most of the day. The light quality usually is quite warm, and it can transform something like a bleak moor into a visual joy of ochres, reds, and browns.

PALETTE
burnt sienna,
cobalt blue,
French ultramarine,
light red,
Payne's gray,
raw sienna,
and sap green

STAGE 1

5 minutes I draw the scene on my watercolor paper with a 4B pencil. Then I begin painting with a light, loose wash of cobalt blue in the sky, scrubbing the paint on with the side of a round brush. While this settles, I wash in the stronger foreground shadows using French ultramarine mixed with light red.

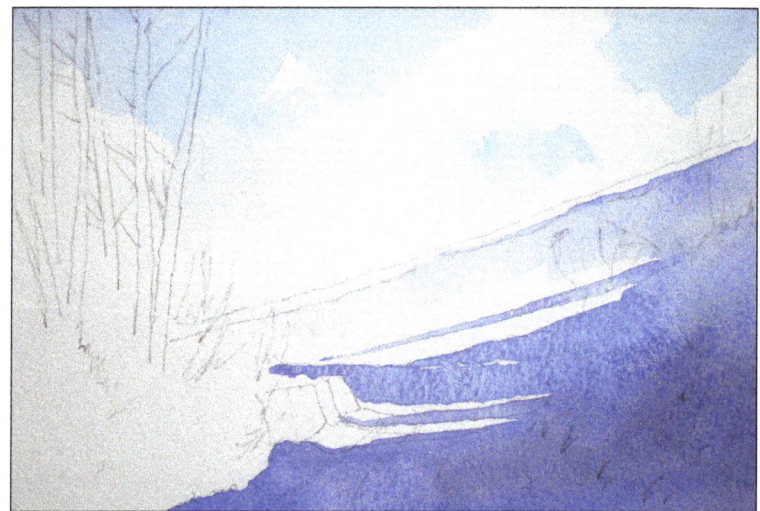

STAGE 2

4 minutes With a very small round brush, I paint the sunlit distant wall and the nearer wall at left using sap green and raw sienna mixed loosely on the paper. I use the same colors plus Payne's gray and burnt sienna to paint the dark stones of the wall in shadow.

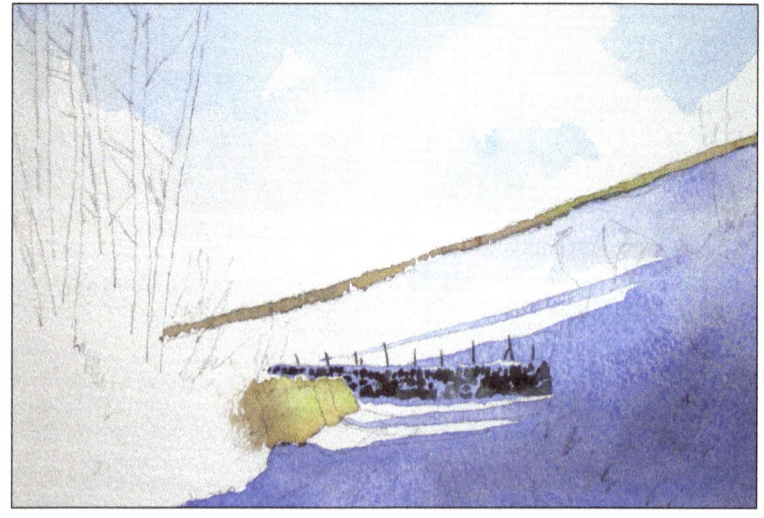

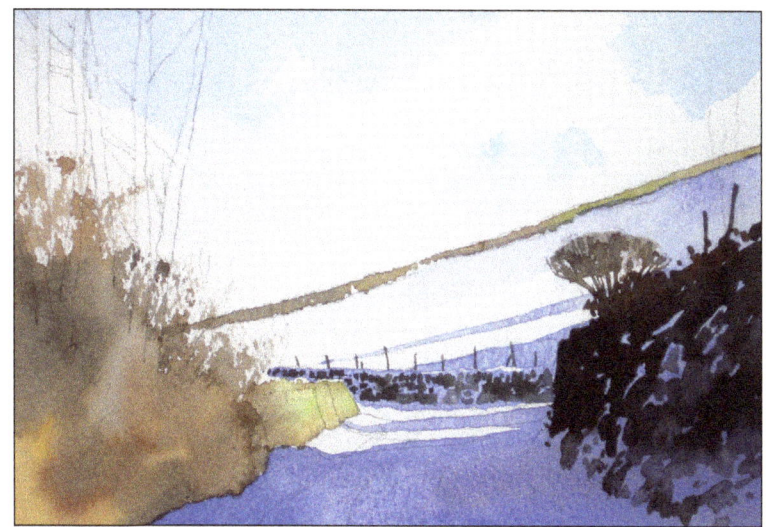

STAGE 3

7 minutes Using the side of a small round brush, I scumble in the area of sunlit bushes on the left with raw sienna, burnt sienna, and Payne's gray, loosely mixing the colors on the paper. On the shadowed side of the lane, the bush is darker and more neutral in color. For this I use a strong mix of burnt sienna and Payne's gray. Although there appears to be careful detail in this section, I actually paint it quickly with only one paintbrush.

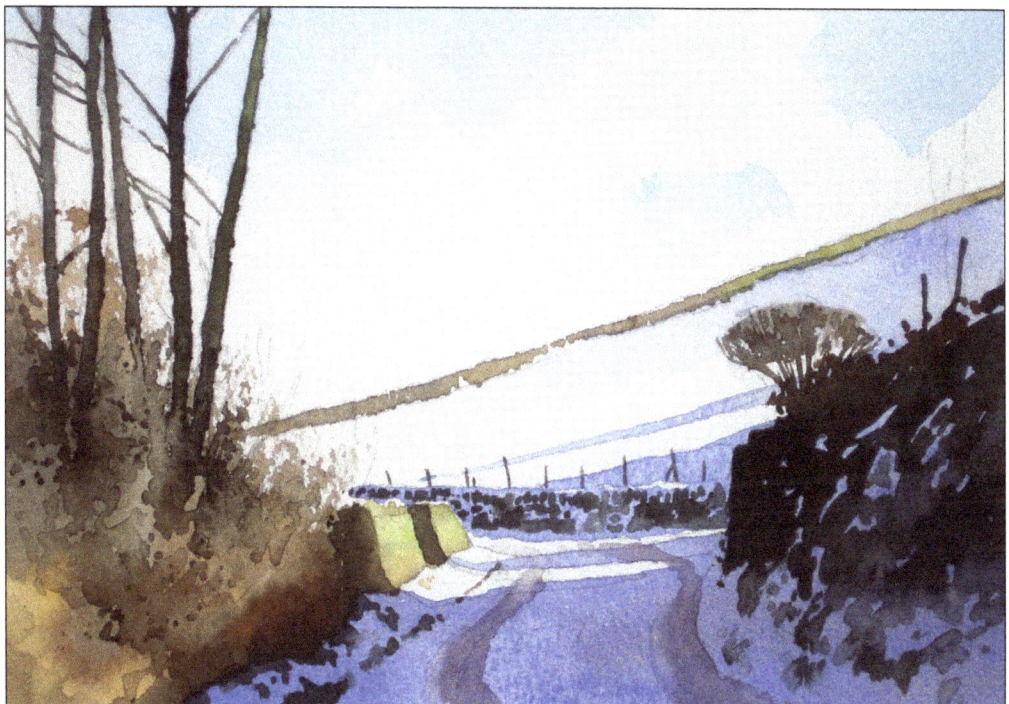

STAGE 4

9 minutes I finish the painting with some detail accents. I paint the tree trunks quite freely using a mix of Payne's gray and burnt sienna. While the paint is still wet, I add some sap green in certain areas for variation. Where the trees meet the bush on the left, I stipple and spatter the mix of Payne's gray and burnt sienna on the paper, softening the shapes here and there with clean water. I find this quick and spontaneous technique to be an excellent replacement for painting too much fine detail. I use Payne's gray and burnt sienna to continue the cast shadows up the sunlit wall, and I finish the painting by adding a couple of tire tracks on the lane with a mix of light red and French ultramarine.

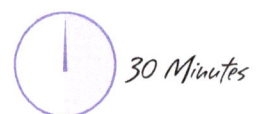 *30 Minutes*

ADDING ANIMALS TO A LANDSCAPE

If you want to become familiar with something, study the detail first. I often use this adage when someone is trying too hard to paint a particular subject. On many occasions I am asked, "How do you paint animals?" There is no other answer than to familiarize yourself with the creature in question by creating your own studies, either from photos or from life. (If you choose to study cattle from life, do so from behind the relative safety of a wall as a precaution.) A great way of learning is to paint the animal close up (preferably from a photo), not only so you can see the shapes but also so you can pick up on the subtlety of color. For instance, at first glance you may see an animal in black-and-white, but when you look beyond the surface impression, you will see that the animal absorbs colors from its surrounding landscape, unifying it in the scene. In this study, I see blue, violet, and green in the cow's hide, and it is these colors that will bring the painting to life.

PALETTE
burnt sienna,
cadmium red,
French ultramarine,
Hooker's green,
Payne's gray,
raw sienna, sap green,
and violet

EXTRA
hair dryer

STAGE 1

4 minutes I draw the shape of the cow with care, as accurate proportions are important when painting animals. With a large round brush, I paint the pale grass with a variegated wash of sap green and raw sienna. I dry the area with a hair dryer and then add the suggestion of background trees with another variegated wash of Hooker's green, French ultramarine, and Payne's gray.

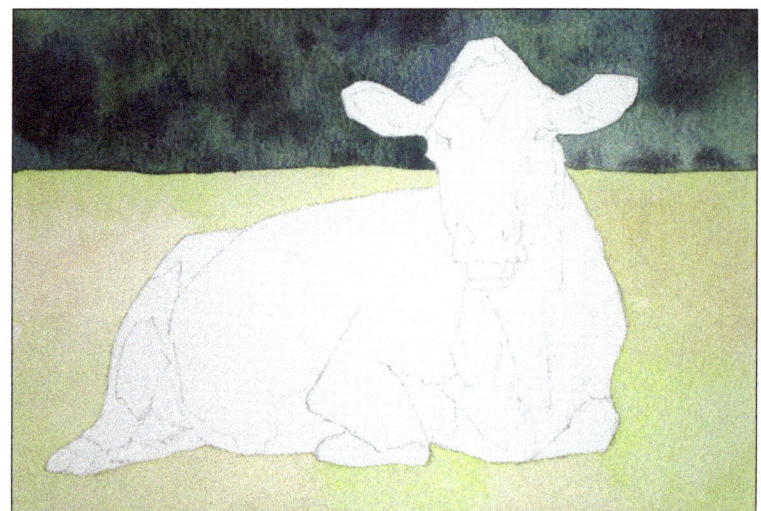

STAGE 2

8 minutes As soon as the background is dry, I block in the colors of the cow. Beginning with the body, I use Payne's gray as the main color but drop other colors into the wash, including violet, French ultramarine, and Hooker's green, as shown. The colors act as a tint and shouldn't be overpowering. Then I add a stronger wash of burnt sienna to the nose area.

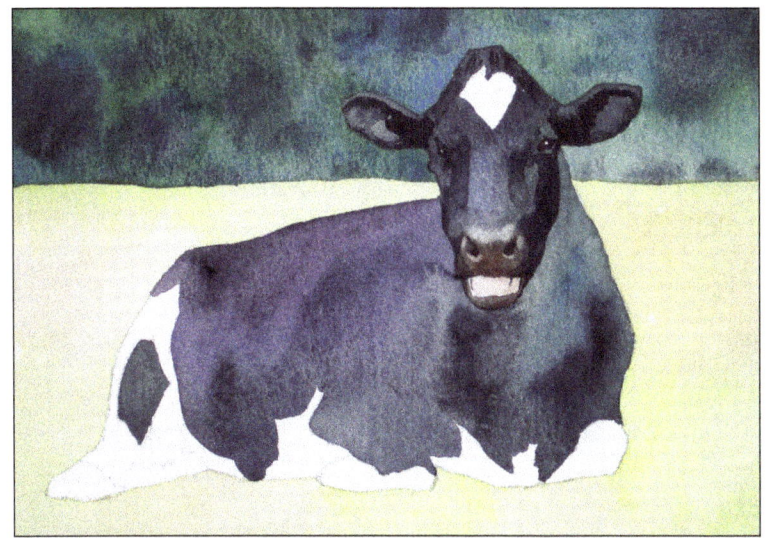

STAGE 3

8 minutes Once the previous washes are dry, I begin working on the shadowed parts of the cow's features using the same colors as in stage 2. I use a very small brush to maintain control over these smaller sections of wash. In places where the shadows have soft edges, I blend the paint with clean water. I work methodically over the head, forming the main shapes of shadow. I create a pale mix of cadmium red and raw sienna for the cow's tongue. Then I carefully lift out some of the dry paint with a clean wet brush for the highlights around the cow's nose.

STAGE 4

10 minutes Using a dark wash of Payne's gray as my base, I add the dark shadow shapes to the cow's body in the same manner as the head, defining the hooves with pale washes. Then I use varying mixes of sap green and French ultramarine to create shadows in the grass.

- *Don't think about the animal you are painting. Instead, look at it as a series of abstract shapes— this will help you paint what you see, not what you think you see.*
- *Leave a small white speck in both of the animal's eyes to bring them to life. If you forget, add a white dot with a bit of white gouache.*

CLOSING WORDS

Now that you've practiced the art of keeping your landscapes fresh and spontaneous, it's time to apply it to your own original pieces of art. Not every watercolor painting can be completed in a half-hour, but remember to continue to push your boundaries: Steer away from including every little detail, apply your strokes loosely and quickly, and keep your colors vibrant. These guidelines are necessary for creating spontaneous, painterly images. After spending some time painting on your own, it's a good idea to return to this book and use the exercises to loosen up and break any bad habits that may be forming. I hope you have found this book inspiring and, above all, that you have fun discovering the keys to success in watercolor!